PITTSBURGH'S RIVERS

IMAGES
of America

PITTSBURGH'S RIVERS

Daniel J. Burns with the Carnegie Library of Pittsburgh

ARCADIA
PUBLISHING

Published by Arcadia Publishing
Charleston, South Carolina

Printed in the United States of America

Library of Congress Catalog Card Number: 2006921821

For all general information contact Arcadia Publishing at:
Telephone 843-853-2070
Fax 843-853-0044
E-mail sales@arcadiapublishing.com
For customer service and orders:
Toll-Free 1-888-313-2665

Visit us on the Internet at www.arcadiapublishing.com

Dedicated to those past and present who have dedicated their lives to the rivers, and to my children Evan, Samantha, and Collin.

CONTENTS

ACKNOWLEDGMENTS

Thanks to Marilyn Holt and Gil Pietrzak in the Pennsylvania Room at the Carnegie Library of Pittsburgh, and my friend Mark Ladner for coming through when I needed that one particular photograph. To Bill Porter, the Pittsburgh staff of Ingram Barge Company, and the crew of the *W. H. Dickhoner*—Ron Fortenberry, Tom Karns, Bill Cartwright, Terry Lanterman, Jeff Simmons, Danny Skamser, Ken White, Jon Turrill, and Deborah Johnson—thank you for making me part of your family. Your knowledge, hospitality, and generosity helped make this book possible. Lastly but certainly not least, to my dearest Sarah, thank you for your unwavering love and support.

INTRODUCTION

After publishing *Duquesne* and *Bedford and Its Neighbors*, I considered many new ideas for another project but kept coming back to the one that interested me most—a book on Pittsburgh's rivers. Since my first childhood ride on the Gateway Clipper's *Good Ship Lollipop*, I have been fascinated with the big boats that are such a common sight on our local waterways. To get started, I checked the book stores and found many wonderful and educational publications. Some had great color pictures while others dictated the history of the region through timelines and essays. What I was looking for, but did not find, was a book that had a bit of everything relating to the three rivers and how they made us who we are and why we are here as Pittsburghers. The end result was this compilation of photographs and information that painted the history of the Monongahela, Ohio, and Allegheny Rivers in broad strokes. I set out to answer some of my own questions such as why does a trainload of coal traveling north pass a barge load of coal going south? Or what is it like to work on a barge, and is it much different today that it was 100 years ago? In the interest of informing and entertaining, I set out to write a book that I wanted to read, and had a little bit of everything.

One

THE BIRTH OF A CITY

In 1753, twenty-one-year-old Maj. George Washington was ordered by Governor Dinwiddie of Virginia to explore and survey the land at the confluence of the rivers in the area today known as Pittsburgh. In a communication to the governor, Washington described the land as "well timbered" and suited for the construction of a fort. In February 1754, construction of a small stronghold named Fort Prince George was begun, but shortly after fell into French and American Indian hands in April of that year. A larger fortification was then built, which the French named Fort Duquesne. (Carnegie Library of Pittsburgh.)

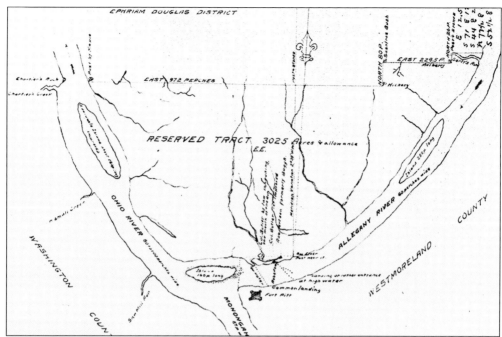

In 1758, after constructing a road through the Pennsylvania wilderness, Brig. Gen. John Forbes captured what remained of Fort Duquesne after the French burned it to the ground. The camp established by Forbes was named "Pittsburgh" after British statesman William Pitt. Fort Pitt was then established at the point of the Monongahela, Ohio, and Allegheny Rivers. (Carnegie Library of Pittsburgh.)

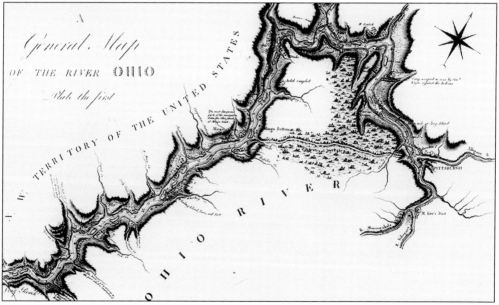

There are a few accounts of explorers who traveled the rivers even before the arrival of George Washington. One of these adventurers was Arnold Viele, a Dutch explorer from Albany, who, with the help of a party of Mohegan and Shawnee Indians, traveled down the Ohio to the Mississippi in 1694. (Carnegie Library of Pittsburgh.)

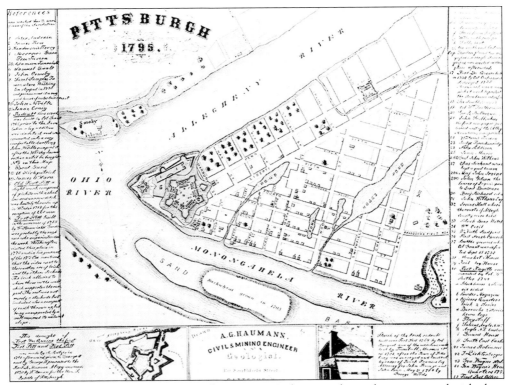

The year 1795 saw the end of nearly all American Indian attacks in the region, and with that, Pittsburgh began to grow from a small wilderness camp into a thriving city, as seen in this map from the Lorant Collection. By 1816, the population topped over 6,000 as Pittsburgh served as the hub of commerce between the east and New Orleans. (Carnegie Library of Pittsburgh.)

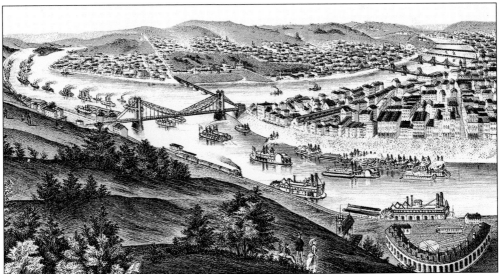

By 1788, Allegheny County had now been established with Pittsburgh as the county seat. In 1816, Pittsburgh was incorporated as a city; and by 1830, the population of the city exceeded 12,000 residents including tradesmen, boatbuilders, and laborers. Pittsburgh was the "Gateway to the West." (Carnegie Library of Pittsburgh.)

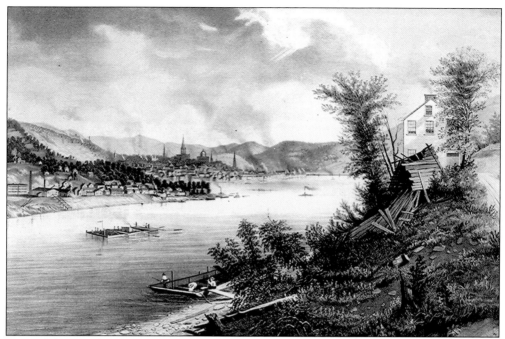

It is well known that during the 20th century, Pittsburgh gained the reputation as the "Smoky City" because of its steel mills and factories. What is not so commonly known is that the city was dubbed the "City of Smoke" in the early 1800s due to its thriving early industries and expanding population. (Carnegie Library of Pittsburgh.)

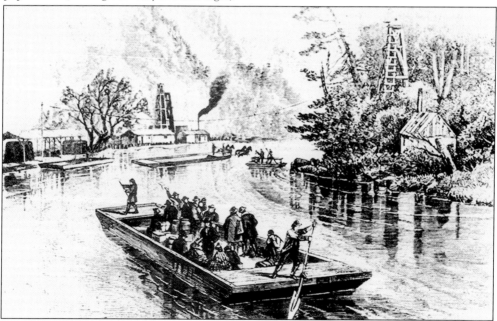

In 1807, a group of farmers from Greensburg, Pennsylvania, sent a load of whiskey, over 500 gallons, down the Ohio River to trade for much-needed supplies such as coffee, flour, and tea. After nearly seven weeks, the group successfully traded for all of their required goods and made a profit of $200. (Carnegie Library of Pittsburgh.)

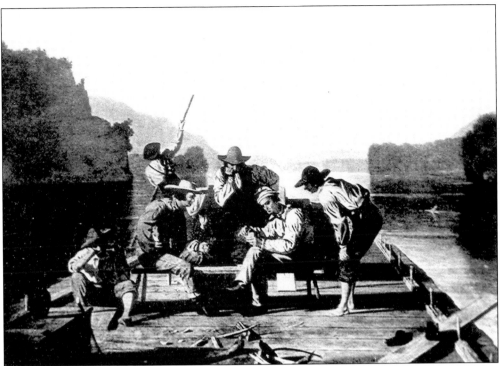

A day in the life of a bargeman, or roustabouts as they were often referred to, in the early 1800s included hard and often dangerous work. While at play, the men enjoyed activities including fishing and playing cards, as seen here. (Carnegie Library of Pittsburgh.)

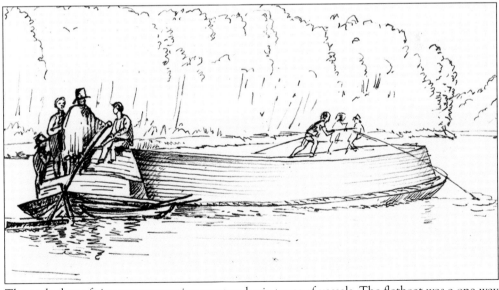

The early days of river transportation saw two basic types of vessels. The flatboat was a one-way or "never come back" boat. When it reached its destination, it was disassembled and its lumber used for the construction of houses, docks, and so on. The keelboat, shown in this 1826 drawing by Charles Leseuer, was used for the transportation of people and goods along the rivers in the days before the steamboat. (Carnegie Library of Pittsburgh.)

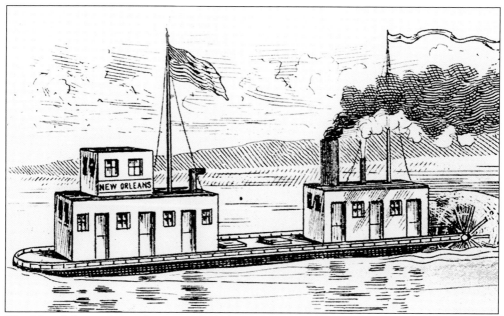

The *New Orleans*, shown here, was built by Robert Fulton, L. R. Livingstone, and Nicholas Roosevelt in 1811. (Carnegie Library of Pittsburgh.)

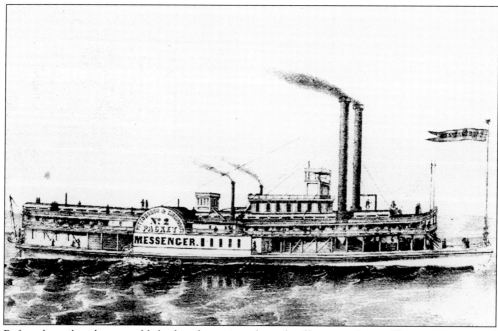

Before the railroad was established in the region, the only efficient and cost-effective way to travel great distances was aboard a packet boat. Packet companies offered transportation from Pittsburgh to as far south as the Mississippi River and New Orleans. (Carnegie Library of Pittsburgh.)

Two

THE MONONGAHELA, OHIO, AND ALLEGHENY

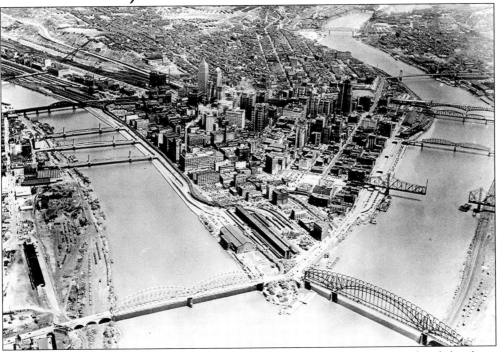

From the time that a community was first established at the confluence, Pittsburgh has been known as the town at the three rivers. During the industrial days of the region, the rivers suffered greatly due to the pollution of the waters and the lack of environmental control. There was a time that none of the rivers were safe to swim in, let alone to drink from. Times have changed and in the past 50 years alone, Pittsburgh's rivers have gone from a repository for industrial waste and sewage to a clean water playground teeming with fish. Pittsburghers take great pride in their city and in the rivers that made this great community. (Carnegie Library of Pittsburgh.)

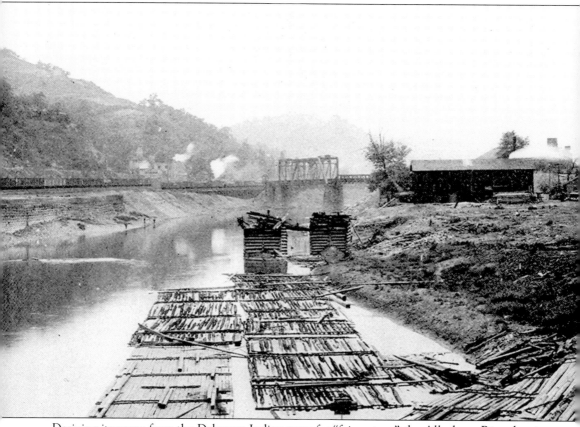

Deriving its name from the Delaware Indian term for "fair waters," the Allegheny River has its origins in north central Pennsylvania near the town of Coudersport. The river flows into New York State before crossing back into Pennsylvania and on into Pittsburgh. There it meets with the Monongahela River to form the Ohio at the Point. Although the Allegheny spans a total of 325 miles, it is only navigable from East Brady, Pennsylvania, about 72 miles upstream from Pittsburgh. (Carnegie Library of Pittsburgh.)

The Allegheny River was at one time used to move vast amounts of lumber from the Allegheny forest to Pittsburgh and beyond. The river was also home to many industrial manufacturers such as Allegheny Steel; the Aluminum Company of America, later known as ALCOA; the Armstrong Cork Company; and the H. J. Heinz Company. (Carnegie Library of Pittsburgh.)

There were many smaller companies in various towns along the Allegheny River that were equally productive to the region. Paper bags were made in Oakmont, bronze products in Tarentum, burial caskets in Blawnox, and machine shop products were manufactured in Aspinwall. Paint was made in Millvale, and sawmills were located along the river in many towns, including Sharpsburg and Verona. (Carnegie Library of Pittsburgh.)

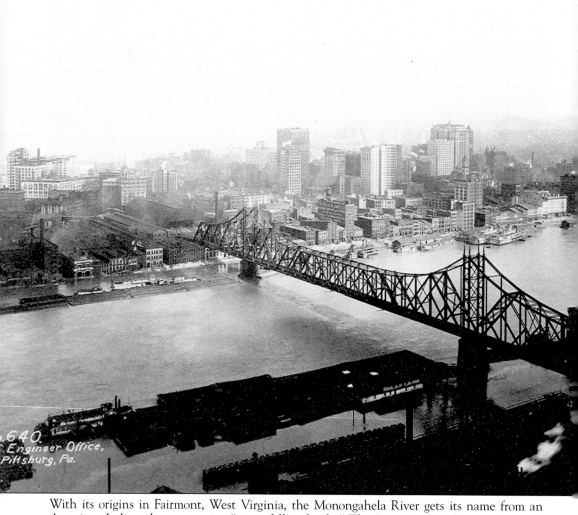

With its origins in Fairmont, West Virginia, the Monongahela River gets its name from an American Indian phrase meaning "steep, falling banks." The "Mon," as it is known, is one of only two rivers in the western hemisphere that flows north. From the beginning to the middle of the 20th century, the Monongahela River was the busiest waterway in the world as it served the steel communities of Homestead, Braddock, Duquesne, and Clairton during the height of the steel making industry. (Carnegie Library of Pittsburgh.)

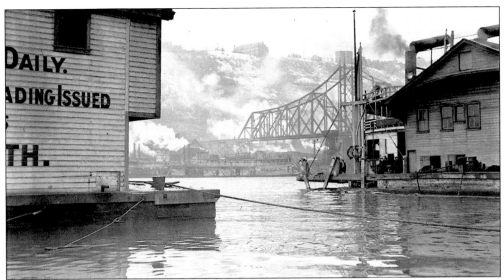

The Monongahela River view from the wharf in Pittsburgh shows "Coal Hill," now known as Mount Washington, in the background. On top of Coal Hill is St. Mary of the Mount Church. Further upstream near Homestead is the site of the locally famous crash of a military B-25 in 1958. (Carnegie Library of Pittsburgh.)

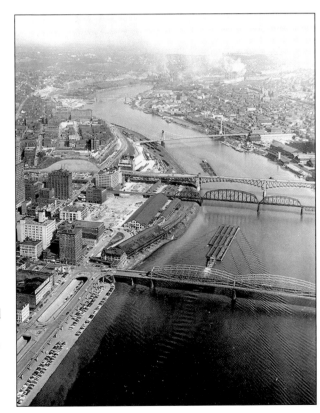

Many views of the Monongahela River show what appears to be dirty water. The Monongahela, in fact, has a mud bottom as opposed to the Ohio, which has a stone and gravel bottom. The propellers of the boats passing on the river stir up this muddy bottom, causing the waters to turn brown. (Carnegie Library of Pittsburgh.)

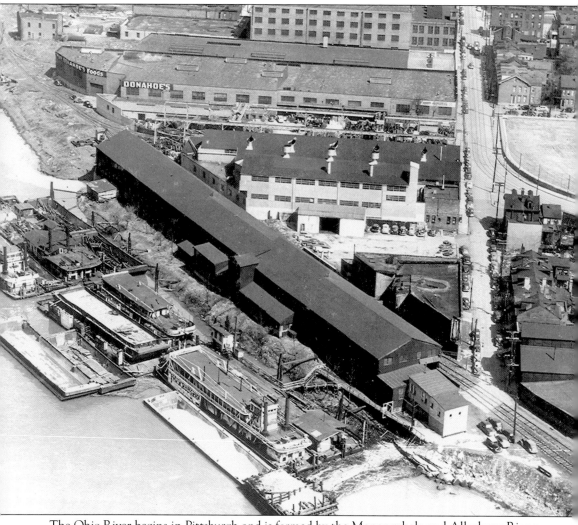

The Ohio River begins in Pittsburgh and is formed by the Monongahela and Allegheny Rivers. It flows 981 miles to Cairo, Illinois, where it meets the Upper Mississippi to form the Lower Mississippi River. Derived from the Seneca Indian word meaning "beautiful waters," the Ohio was thought to be inhabited by evil spirits who dwelled in the dark water. Because of the movement of material from the Allegheny Region to the Mississippi, more tonnage is transported on the Ohio River than through the Panama Canal every year. (Carnegie Library of Pittsburgh.)

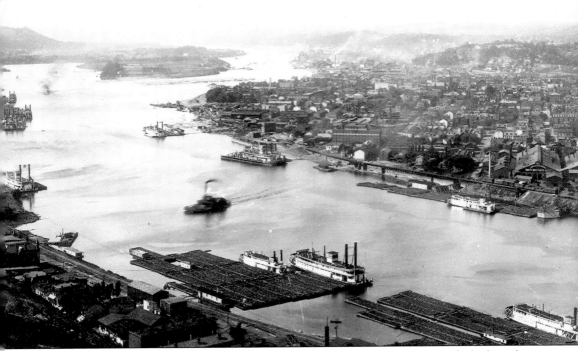

There are countless tales of legend and lore relating to the area's rivers, one of which is the story told by steamboat captains in the 1930s who saw an eerie yellowish light along the shore of the Ohio River. Many believe it had something to do with the wreck of the *Kanawha*, a packet boat that capsized, killing all aboard on a cold February night in 1916. (Carnegie Library of Pittsburgh.)

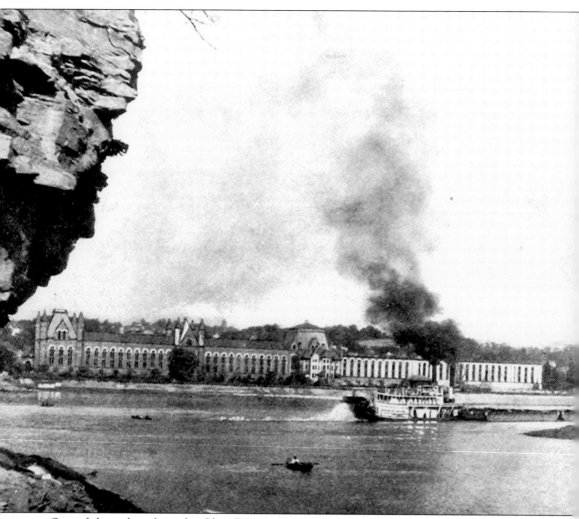

One of the sights along the Ohio River is the Western State Penitentiary. Opened in 1882, it was the first state prison built west of the Allegheny Mountains. Known by its residents as "the Wall," the prison had 1,100 cells that housed over 1,500 inmates, and was one of just a few maximum security prisons in Western Pennsylvania. In 2005, the prison was closed after it was deemed too antiquated to remain a viable facility. (Carnegie Library of Pittsburgh.)

Three

THE GRAND BOATS
OF YESTERDAY

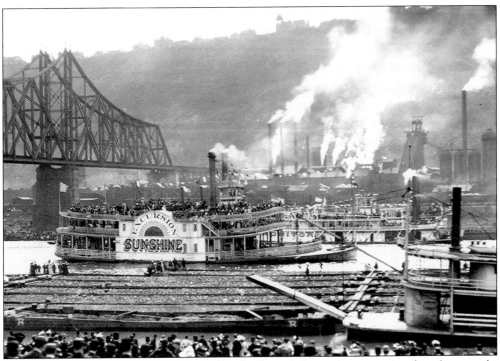

When multi-decked riverboats, large paddle wheels, and the smoke emanating from large stacks on top of a grand steamship are thought of, Mark Twain's *Adventures of Huckleberry Finn* and the mighty Mississippi come to mind. What many people are not aware of is the fact that these images can be found in the history of one's own backyard. One of Pittsburgh's legacies is that these grand vessels traveled the Monongahela, Ohio, and Allegheny Rivers working for the industries that built the economy. (Carnegie Library of Pittsburgh.)

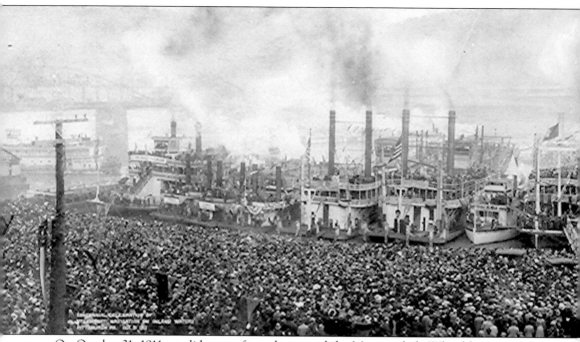

On October 31, 1911, a solid mass of people covered the Monongahela Wharf from Smithfield Street to the Point for the centennial celebration of steamboat navigation on inland waters. The main boat of interest was a replica of the first river steamboat *New Orleans*, which was built here in 1811. As a band played "Alice, Where Art Thou?" the boat was christened by Alice

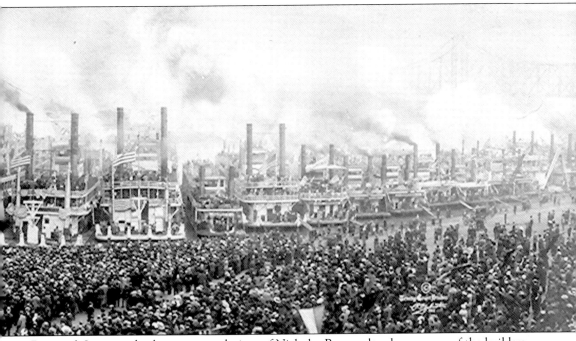

Roosevelt-Longworth, the great-grand-niece of Nicholas Roosevelt, who was one of the builders of the original *New Orleans*. Roosevelt-Longworth was escorted by Pittsburgh mayor W. A. Magee and President Taft. This photograph was taken by R. W. Johnston from the top of a telephone pole on Wood Street. (Carnegie Library of Pittsburgh.)

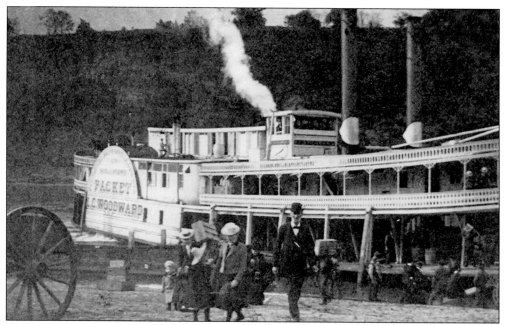

In the 1800s, the romantic and exciting way to travel was to take a steamboat to your destination. Even a Pittsburgh area court in 1850 officially ruled, "No matter how important railroads become, they can never hope to rival river transport." As time went on, however, riverboats moved fewer passengers and more cargos of coal, gravel, and other industrial loads. (Carnegie Library of Pittsburgh.)

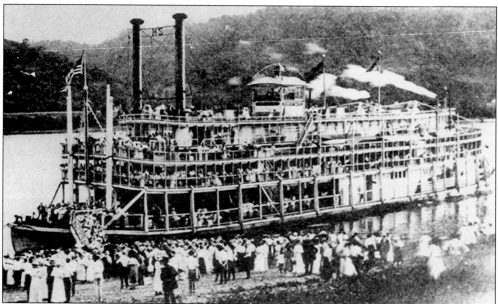

In the days before a carrier was concerned with the safety of its passengers, often the goal was to get as many aboard as possible. More fares meant more revenue. Even after tragedies such as the boating disaster in New York in 1904 that claimed over 1,000 lives, boat owners and crews were undaunted and continued to pack them on without regard to safety. (Carnegie Library of Pittsburgh.)

If one needed to get around in the Pittsburgh area and beyond, most often the choice was to travel by boat. It was more economical than coach, and often boats ran more frequently than trains. (Carnegie Library of Pittsburgh.)

H. L. JOHNSON, Master. GEO. J. WIEGEL, Clerk.

Pittsburgh, McKeesport and Elizabeth Packet.

STEAMER LEE H. BROOKS.

Leaves Pittsburgh Wharf every day, except Sunday, at 2.30 P. M. for all Points Between Pittsburgh and Elizabeth.

Office, No. 100 WATER STREET,

Telephone 204. PITTSBURGH, PA.

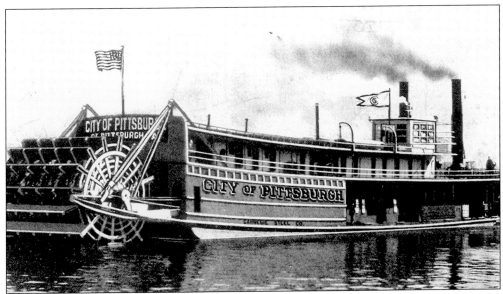

Among the many goods that had to be transported along Pittsburgh's rivers was oil. By the 1870s, there were over 60 refineries in the city of Pittsburgh alone, producing over 36,000 barrels a day. (Carnegie Library of Pittsburgh.)

Many packet boat companies, like the one shown here, offered transport to many cities in the west. Depending on the traveler's economic abilities and social status, a passenger could travel in a finely appointed cabin or on deck with a canvas tarp and blanket. (Carnegie Library of Pittsburgh.)

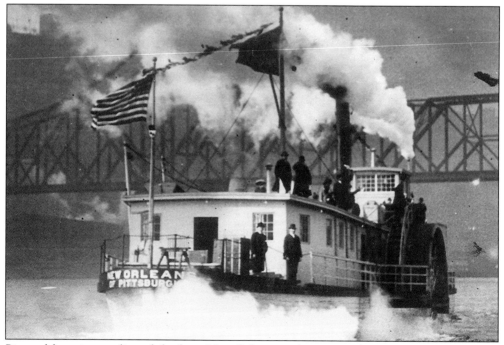

Pictured here is a replica of the boat *New Orleans* underway on the Monongahela River in Pittsburgh during the 1911 celebration of 100 years of steamship travel. (Carnegie Library of Pittsburgh.)

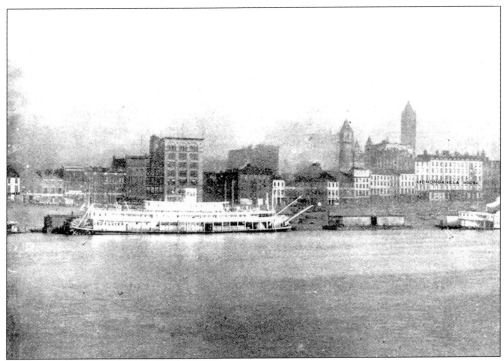

It was said that throughout the 1800s, some of the ship's deckhands and crew worked for free on steamers bound for New Orleans. These men labored in dangerous conditions without pay just for the opportunity to visit the famous brothels in the French Quarter. (Carnegie Library of Pittsburgh.)

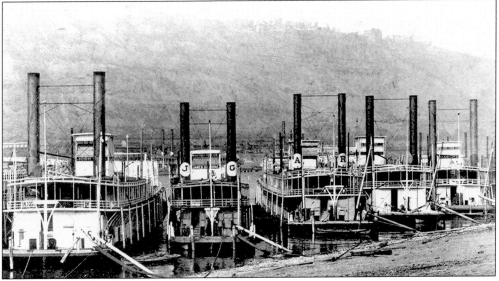

There were literally dozens of riverboats that graced the waters of Pittsburgh's rivers at or near the beginning of the 20th century. Although most of these vessels are long forgotten, some of the well-known boats of the day included the *Twilight*, the *William Bonner*, the *Joseph Nixon*, the *Beaver*, the *Josh Cook*, the *Hornet No. 2*, the *Smoky City*, the *Ironsides*, and the *Iron Duke*. (Carnegie Library of Pittsburgh.)

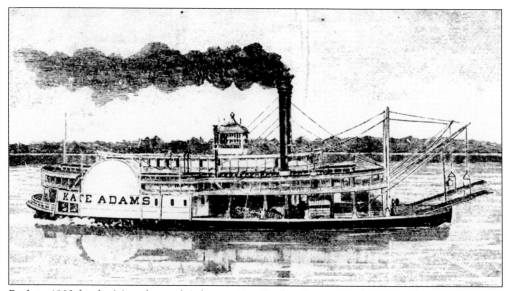

Built in 1882 for the Memphis and Arkansas City Packet Company, the *Kate Adams* was 245 feet long and 37 feet wide. Its passenger cabins were paneled with mahogany and bird's-eye maple, and it was equipped with five steam boilers, which helped make it one of the fastest ships on the Mississippi. (Carnegie Library of Pittsburgh.)

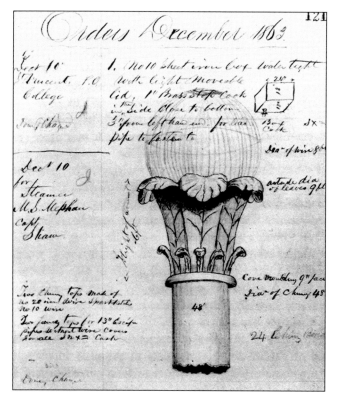

A tin plate business started by Jeffrey Scaife saw many of the products designed by son William Scaife. Shown here is a sketch of the chimney designed by William for the steamboat *Paul Jones*, the boat on which Mark Twain had his first lesson in river piloting. (Carnegie Library of Pittsburgh.)

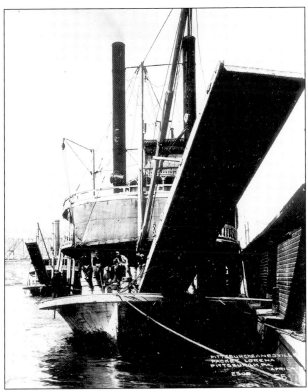

Shown here is the packet boat *Lorena* as it prepares to depart Pittsburgh for Zanesville. Trips such as this were usually made daily. (Carnegie Library of Pittsburgh.)

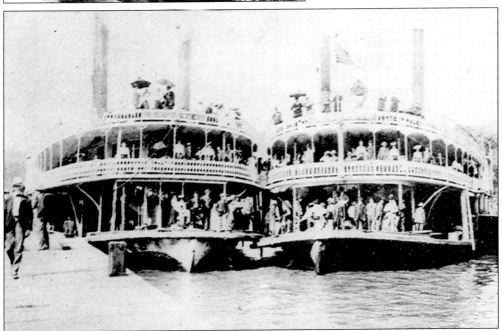

With safety, caution, and common sense cast to the wind, two fully passenger-laden steamships race to be first in a river lock. One has to wonder which was louder, the cheers from the winning boat's passengers or the screams of terror emanating from the losers. (Carnegie Library of Pittsburgh.)

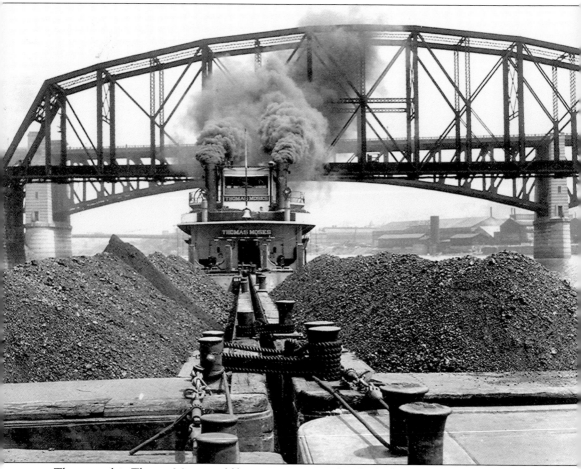

The steamship *Thomas Moses* could be seen moving coal and coke barges along the Monongahela between Clairton and Homestead. This boat, like many others on the river, employed a full crew compliment who worked 24 hours a day, seven days a week, to feed the mighty furnaces of the steel manufacturing mills. (Carnegie Library of Pittsburgh.)

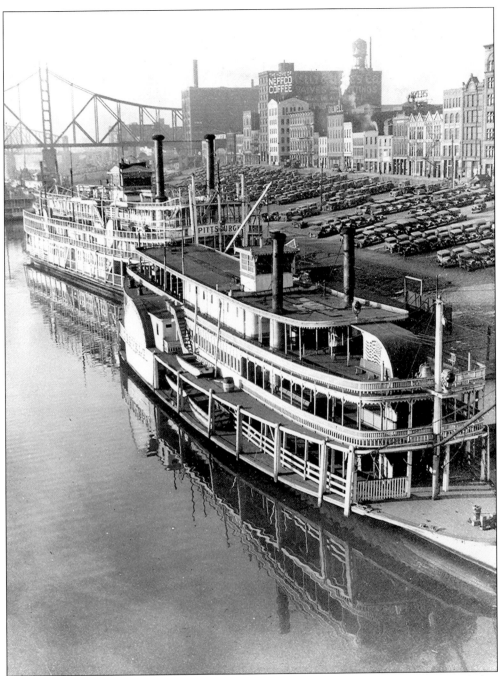

In January 1884, Charles Dickens, along with his secretary, wife, and her maid, traveled to America. After a tour of the East Coast, Dickens and his party boarded the steamboat *Messenger* in Pittsburgh and headed down the Ohio. He described the ship as "One among a crowd of high-pressure steamboats, clustered together by a wharf-side which looked down upon the rising ground that forms the landing place. She had forty-some passengers on board, exclusive of the poorer persons on the lower deck." (Carnegie Library of Pittsburgh.)

In some cases, if you needed transportation from one place on the river to another, it paid to know someone who worked on the barges. Passengers just had to weigh the cost of a ticket versus a clothes cleaning bill. (Carnegie Library of Pittsburgh.)

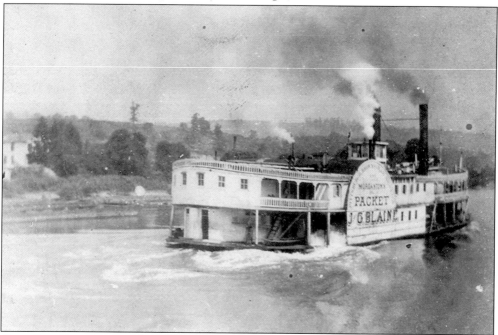

Capt. Ezra Young, a veteran river man from the late 1800s, once remarked that some of the finest riverboats made were constructed in the Pittsburgh area. "All of the Cincinnati packet boats were built here including the 'Keystone State,' the 'Buckeye State,' the 'Allegheny' and the 'Pennsylvania.'" The *J. G. Blaine* was also built in Pittsburgh. (Carnegie Library of Pittsburgh.)

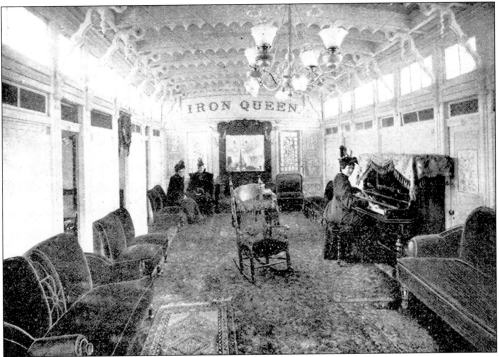

Some who traveled the rivers traveled in style. The *Iron Queen*, pictured here, was richly appointed with plush chairs and elegant staterooms. The $12 to $15 cost for a round trip to Cincinnati, which included meals and berths, was a bit extravagant for some, but well worth the price. (Carnegie Library of Pittsburgh.)

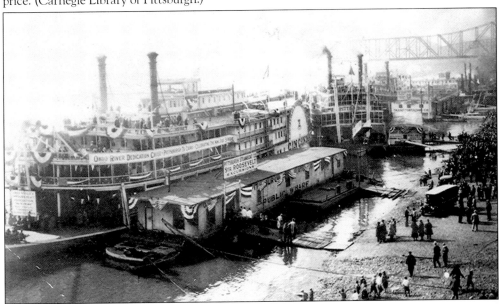

Packet tours and river excursions created many business opportunities not just for boats and their crews but for many young men on the shore. An industrious lad working on the wharf could make up to 40¢ or 50¢ a day carrying baggage or, with a bucket of river water, washing a passenger's motorcar parked nearby. (Carnegie Library of Pittsburgh.)

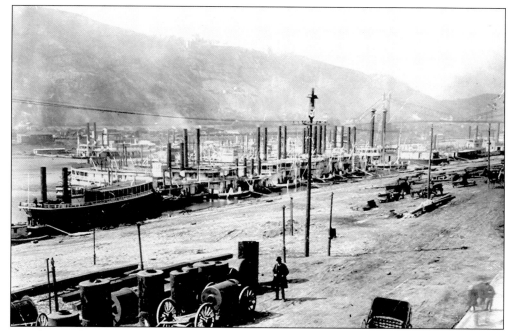

Dated 1896, this photograph shows a typical day along the Monongahela Wharf as boats lined up, often waiting for weeks for the spring rains. This was a common sight before the construction of locks and dams, which ensured year-round water levels high enough to support river traffic. (Carnegie Library of Pittsburgh.)

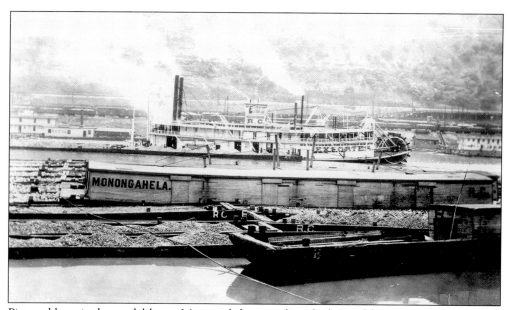

Pictured here is the model barge *Monongahela* at work with the coal barges on the river. This boat was the same one that carried the Pinkerton guards to the Homestead landing during the steel strike of 1892. (Carnegie Library of Pittsburgh.)

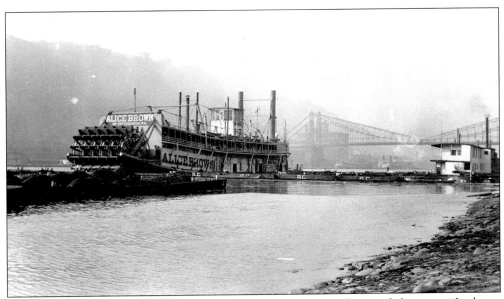

The *Alice Brown* of Pittsburgh was one of the many working boats of the rivers. Its large, steam-driven stern paddle wheel gave it enough thrust to push 30 barges full in one tow as seen here on the Monongahela River. (Carnegie Library of Pittsburgh.)

The *Island Queen* was a steamship built in Midland, Pennsylvania, in 1925 for excursions primarily on the Ohio and Upper Mississippi Rivers. It had been recently modernized and upgraded before its explosion and fire in September 1947. The ship was destroyed during its first trip to Pittsburgh in over 16 years. (Carnegie Library of Pittsburgh.)

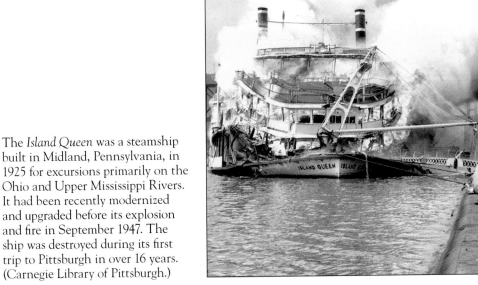

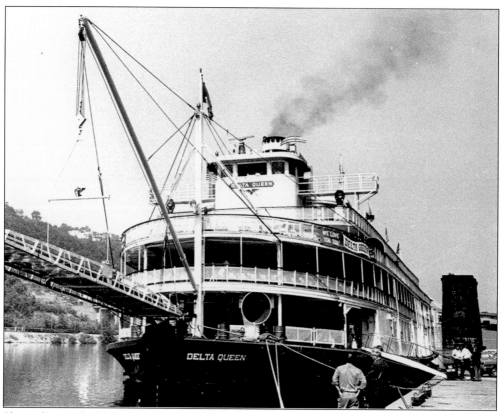

Shown here is the *Delta Queen*, one of the Mississippi River ships that visited the Pittsburgh area. Many of these vessels have lavish sleeping accommodations, fine dining, and entertainment for their passengers. (Carnegie Library of Pittsburgh.)

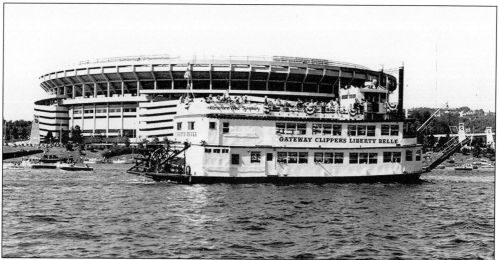

One of the fondest childhood memories that many Pittsburghers have is taking a ride on the Gateway Clipper's *Good Ship Lollipop*. Established in 1958, the Gateway Clipper Fleet offers dinner dance cruises, sightseeing tours, and, of course, children's cruises complete with balloons and clowns. (Carnegie Library of Pittsburgh.)

Four

RIVER CROSSINGS

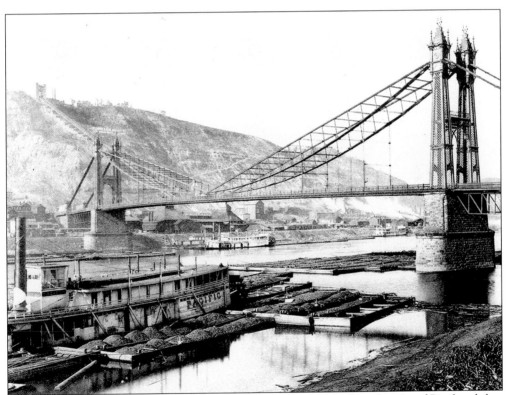

Because Pittsburgh is a city of rivers, it is also a city of bridges. In fact, the city of Pittsburgh has 120 bridges, 30 of which cross one of the three rivers. The bridges themselves are as diverse as the people who travel them. Some are ornate with fancy iron scrollwork while others are plain and unassuming. Yet no matter how the structures are ornamented, they share one commonality—they stand strong, linking Pittsburgh's communities and neighborhoods together. (Carnegie Library of Pittsburgh.)

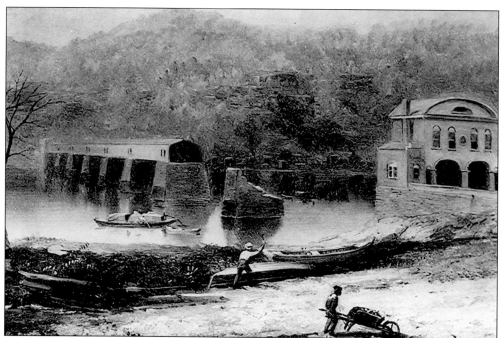

Built in 1818, the Monongahela Bridge was constructed at a cost of $110,000 and employed a toll taker who enforced the following rate structure: foot passengers paid 2¢, a horse and rider was 6¢, and sheep were 3¢ a head. It was repaired after part of the structure fell into the river after a heavy rain in 1832. (Carnegie Library of Pittsburgh.)

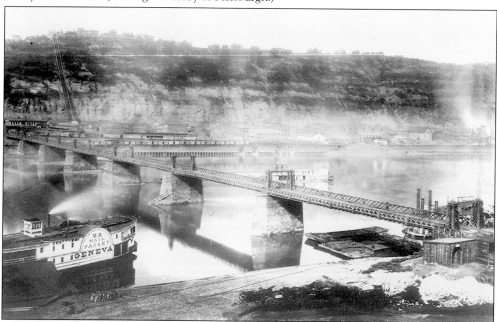

Constructed to replace the first Monongahela Bridge, which was a wooden structure destroyed by fire in 1845, this second Monongahela Bridge was erected in 1846. In 1882, it was decided that the bridge needed to be replaced to accommodate the increased weight of traffic and loads. (Carnegie Library of Pittsburgh.)

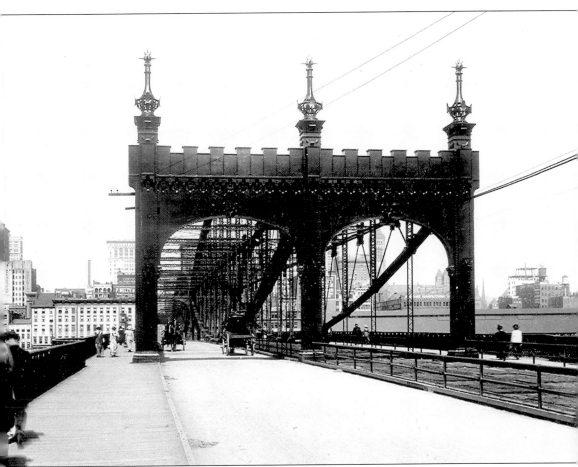

The third of three bridges to occupy the same site is the Smithfield Street Bridge. The oldest river-crossing bridge in Pittsburgh, it replaced the second Monongahela Bridge in the same location. Completed in 1883, it was designed by engineer Gustav Lindenthal, who saw the need to separate the foot traffic from the horse-drawn rail traffic, as seen here. The original span was designed with ornate depictions including the city of Pittsburgh's coat of arms. Traveled by thousands of people everyday, the Smithfield Street Bridge connects downtown with the South Side and Station Square. (Carnegie Library of Pittsburgh.)

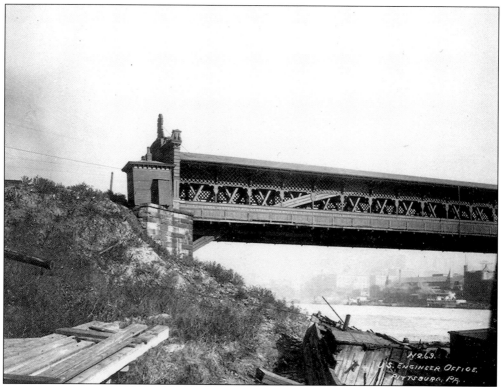

The Union Bridge, as seen here in 1902, opened to traffic in 1875. It was the last wooden bridge constructed in Pittsburgh and spanned the Allegheny River near the Point. It was demolished in 1907 after it was deemed a problem to river navigation due to its low height and numerous piers in the river. (Carnegie Library of Pittsburgh.)

No. 270

Office of the Company for erecting a Bridge over the Allegheny River, opposite Pittsburgh, in the County of Allegheny.

Pittsburgh, *April 1* 186 9

Received of *H W Bancroft* *Two* Dollars, 100

for which he may cross the Bridge on foot

to the first day of *October* *next.*

☛ All yearly toll must be paid in advance, as no person will be allowed to cross at the yearly rate until the toll is paid. And it is expressly understood and agreed, that the person holding this receipt shall exhibit the same whenever required, or forfeit the privilege above granted, and that it is not transferable.

$2

This Allegheny River yearly bridge toll receipt was dated April 1, 1869, but was no April fool. To cross the rivers, people were required to purchase a yearly pass for $2. By the beginning of the 1900s, tolls became a thing of the past as many bridges were purchased by municipalities from private companies. (Carnegie Library of Pittsburgh.)

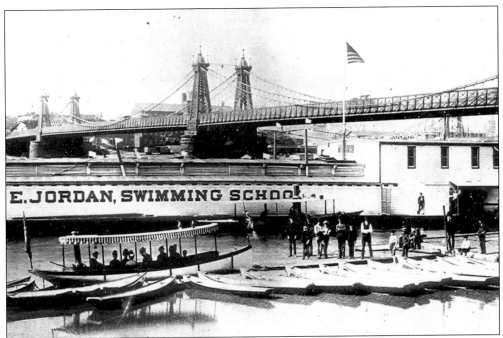

Bridges offered more than a method for travel from one shore of a river to another. They offered the opportunity to fish from their piers and attach rope swings to and dive off their abutments. (Carnegie Library of Pittsburgh.)

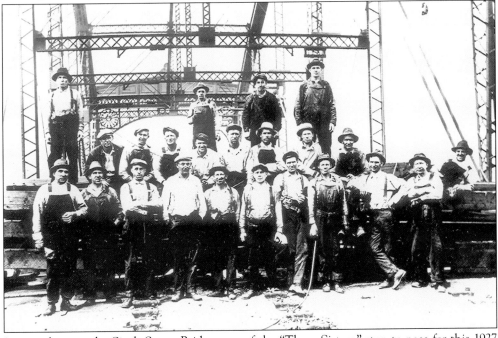

Iron workers on the Sixth Street Bridge, one of the "Three Sisters," stop to pose for this 1927 photograph. Sixth Street was formerly known as Saint Clair Street. In 1999, the bridge was renamed in honor of Pittsburgh Pirate Roberto Clemente, who died in a 1972 plane crash. (Carnegie Library of Pittsburgh.)

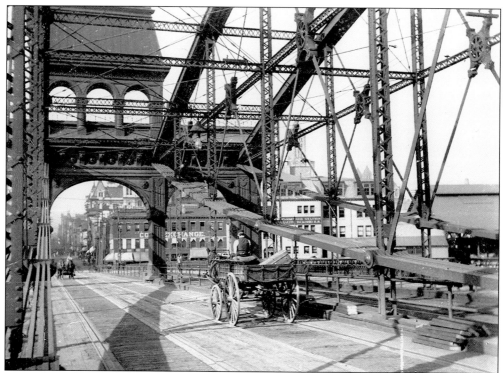

There are a total of 2,139 bridges in Allegheny County. This includes 120 in the city of Pittsburgh and 2,019 in the surrounding municipalities. (Carnegie Library of Pittsburgh.)

Pictured here is the old Ninth Street Bridge. Built in 1840 and also known as the Hand Street Bridge, it was a large, covered wooden structure that spanned the Allegheny River for nearly 80 years before it was demolished due to structural problems. (Carnegie Library of Pittsburgh.)

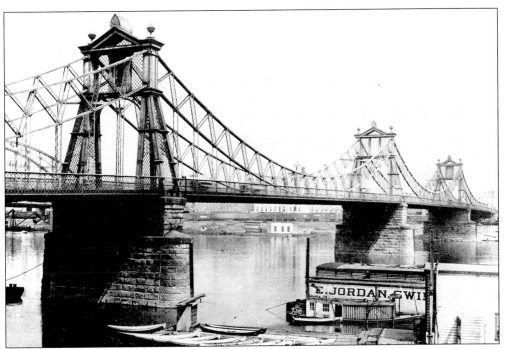

The Seventh Street Bridge, as seen here in this 1893 photograph, was built in 1884 and was also designed by Gustav Lindenthal, the builder of the Smithfield Street Bridge. (Carnegie Library of Pittsburgh.)

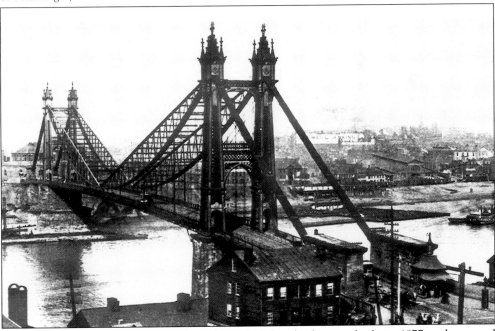

One of two side-by-side Point Bridges, this 1,000-foot bridge was built in 1877 and spanned the Monongahela River. A favorite among Pittsburgh historians and river enthusiasts, this Point Bridge is most recognizable by its ornate spires and iron structure. (Carnegie Library of Pittsburgh.)

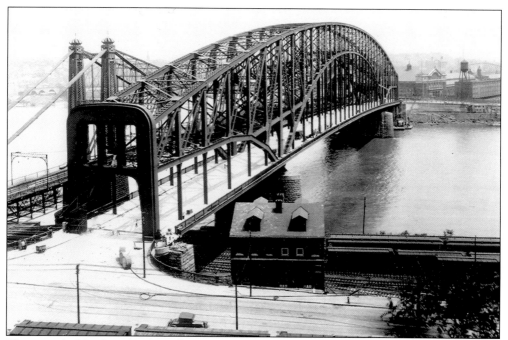

The second of the Point Bridges, this structure was built upstream and placed beside the existing bridge. The span was demolished in 1970 during the renovation of Point State Park. Although the bridge is gone, the southern abutment still stands. (Carnegie Library of Pittsburgh.)

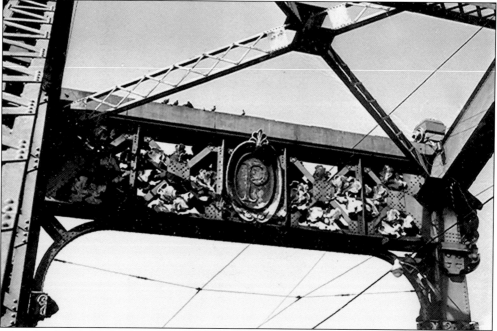

The Manchester Bridge was constructed in 1915 and spanned nearly 2,900 feet, crossing the Allegheny River from downtown to the North Shore. Locally known for its ornate and historic sculptures, the bridge was demolished in 1970, but the sculptures were saved. (Carnegie Library of Pittsburgh.)

In addition to the elaborate scrollwork and coats of arms, sculptor Charles Keck also adorned the Manchester Bridge with likenesses of Christopher Gist, traveling companion to George Washington; American Indian chief Guyasute; and industrial heroes Joe Magarac and Jan Volkanik. (Carnegie Library of Pittsburgh.)

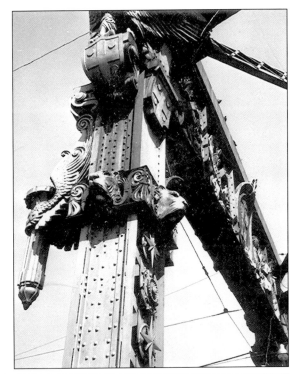

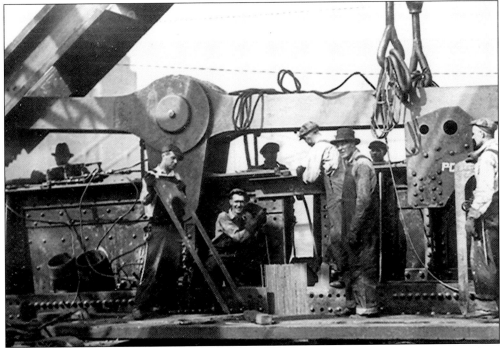

In the 1800s, many regional companies vied for local bridge construction projects. These companies included King Bridge of Cleveland, Edgemoor Bridge of Delaware, Groton Bridge and Manufacturing from New York, and Pittsburgh's own Penn Bridge and Pittsburgh Bridge Companies. (Carnegie Library of Pittsburgh.)

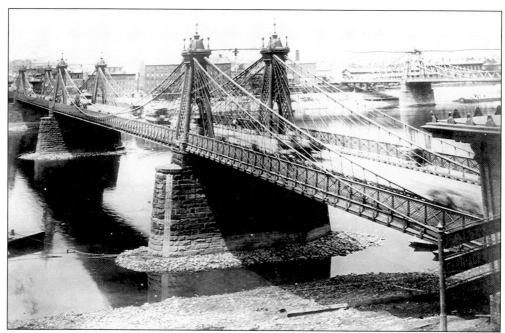

The old Sixth Street Bridge, erected in 1860, was designed by John Roebling, a German immigrant who also designed the Cincinnati-Covington Bridge and New York's Brooklyn Bridge. (Carnegie Library of Pittsburgh.)

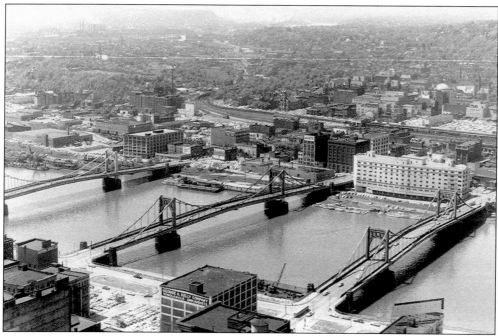

The Roberto Clemente, Seventh Street, and Ninth Street Bridges, also known as the Three Sisters, today cross the Allegheny River and connect downtown Pittsburgh with the North Side, once named "Allegheny City." (Carnegie Library of Pittsburgh.)

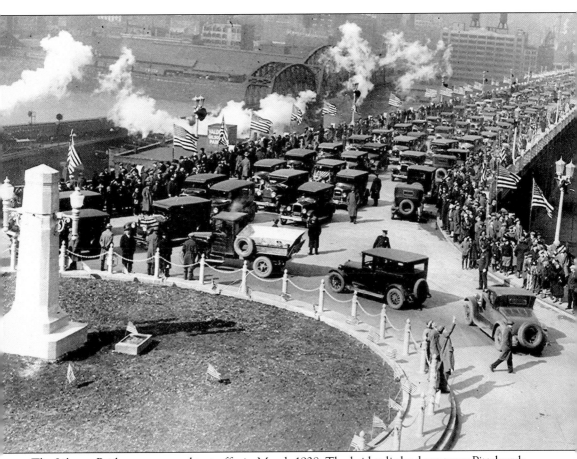

The Liberty Bridge was opened to traffic in March 1928. The bridge links downtown Pittsburgh to the South Hills via the Liberty Tunnels, also known as the "Tubes." Taking three years to construct at a cost of $3.4 million, motorists could now drive from town, across the bridge, and either into the tunnels or turn onto roadways leading either to Mount Washington or the South Side. One interesting impact that the opening of the bridge and tunnels had was that property values in one community on the far end of the tunnel nearly quadrupled. Today the Liberty Bridge is the most heavily traveled non-interstate bridge in the city. (Carnegie Library of Pittsburgh.)

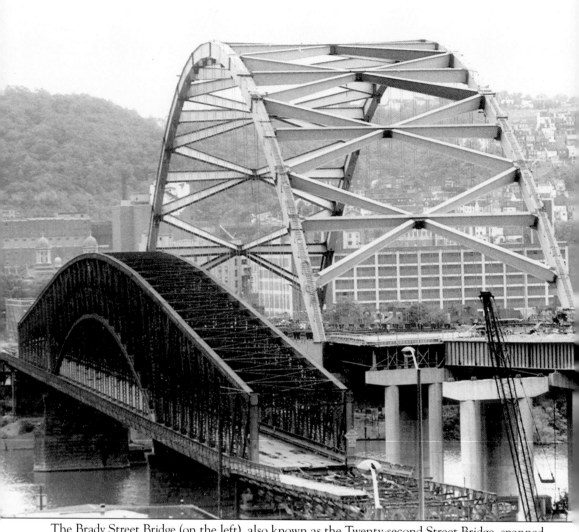

The Brady Street Bridge (on the left), also known as the Twenty-second Street Bridge, spanned the Monongahela River and connected Pittsburgh's South Side with the uptown section of the city. Built in 1896 by the Schultz Bridge and Iron Company of Pittsburgh at a cost of $400,000, it opened to much fanfare and celebration. After 71 years, the bridge was deemed unsafe for vehicle traffic and closed. In 1968, the bridge was demolished and the Birmingham Bridge was constructed. Interestingly, the old bridge did not give up without a fight. While dismantling the iron structure, a worker was trapped atop the structure and had to be rescued. (Carnegie Library of Pittsburgh.)

Five

THE WHARFS

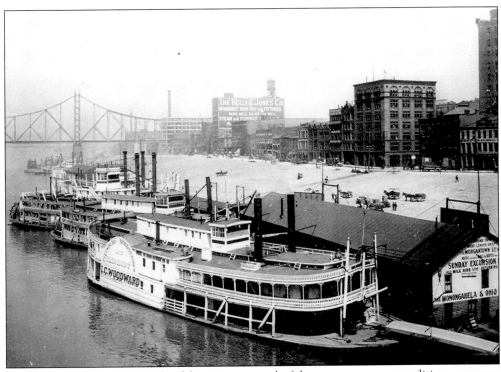

The Monongahela River Wharf has its own colorful past as many expeditions, western explorations, and historically significant events began on the shore of the Monongahela. In 1770, George Washington made his exploration down the Ohio as he began his journey from the bank of the Monongahela near the Point. It was also from the Monongahela Wharf that a steamboat made its first inland cruise from Pittsburgh in 1811. (Carnegie Library of Pittsburgh.)

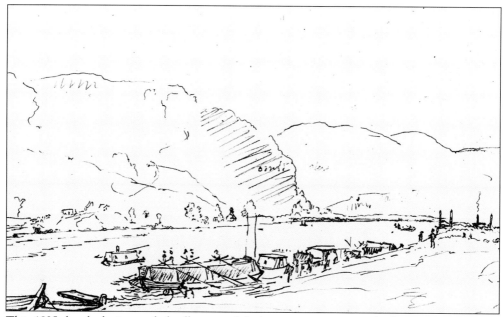

This 1825 sketch depicts early keelboats and flatboats preparing to embark on journeys to the south via the Ohio and Mississippi Rivers. (Carnegie Library of Pittsburgh.)

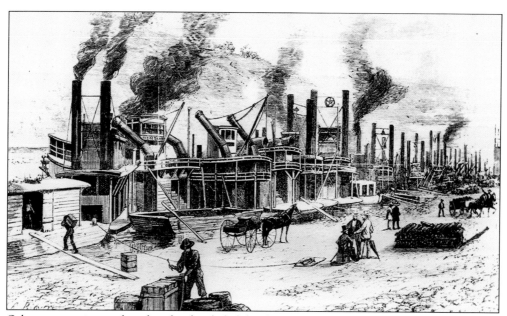

Other events witnessed on the wharf included the shipment of supplies to Gen. Andrew Jackson's army in New Orleans during the War of 1812, and an 1817 visit from James Monroe, the first U.S. president to come to Pittsburgh. (Carnegie Library of Pittsburgh.)

Seen here is a view from the Point looking up the Monongahela toward the Smithfield Street Bridge in 1912. (Carnegie Library of Pittsburgh.)

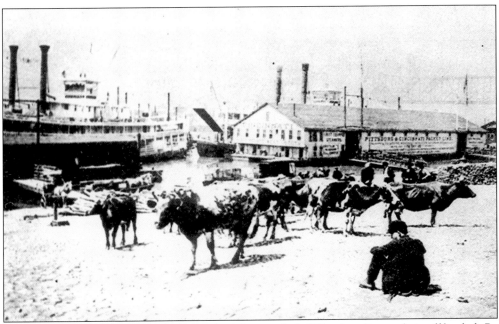

Taken in 1911, this photograph shows the Monongahela Wharf as livestock is off-loaded. By this time, the packet boat and river travel industry was waning due to the railroad and the automobile. (Carnegie Library of Pittsburgh.)

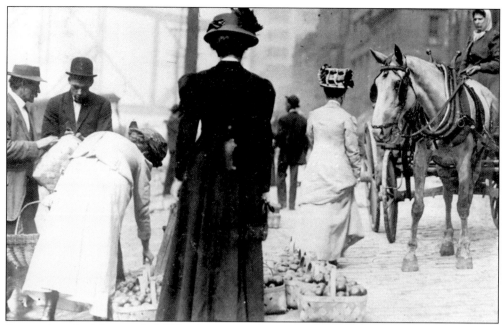

At one time, the Monongahela Wharf was a popular open market for goods and produce shipped into the city and off-loaded at the riverbank. (Carnegie Library of Pittsburgh.)

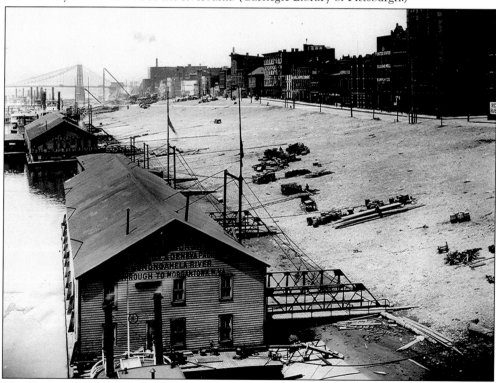

The Monongahela River Wharf was the home for many of the packet boat companies, including the Monongahela and Ohio Boat Company, the Pittsburgh Steamboat Company, and the Pittsburgh, Cincinnati and Louisville Packet Boat Company. (Carnegie Library of Pittsburgh.)

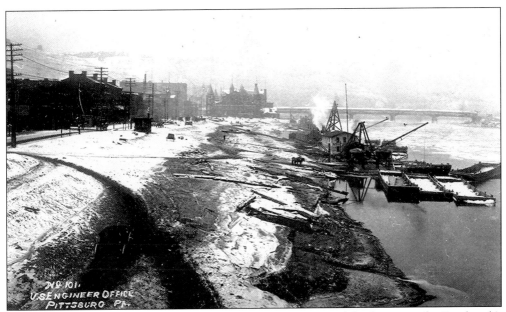

As the Monongahela River Wharf was usually the commercial loading area for Pittsburgh's products and goods, the Allegheny River Wharf, as seen in 1903, was often the industrial equipment and storage area for the city. (Carnegie Library of Pittsburgh.)

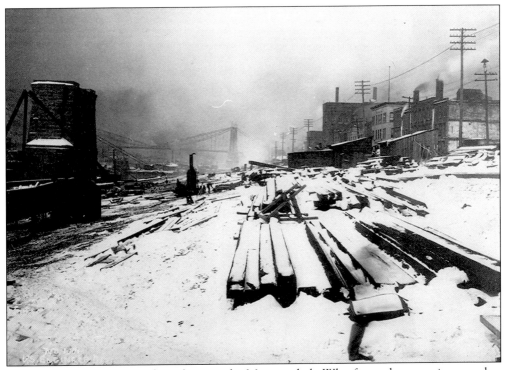

Not always a pretty picture for sightseers, the Monongahela Wharf was also sometimes used as a staging area for industrial companies that stored iron, steel, wood, and other materials on the riverbank before being loaded onto barges. (Carnegie Library of Pittsburgh.)

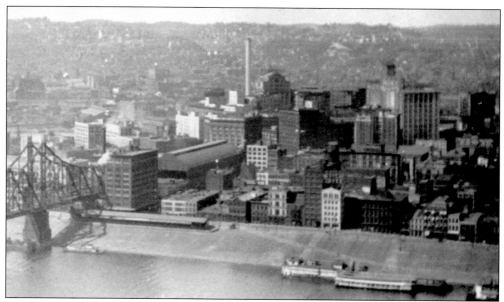

The Monongahela Wharf as seen from Mount Washington shows Water Street before the construction of the Parkway East that was built to meet the high car and truck demands of the 1940s and 1950s. (Carnegie Library of Pittsburgh.)

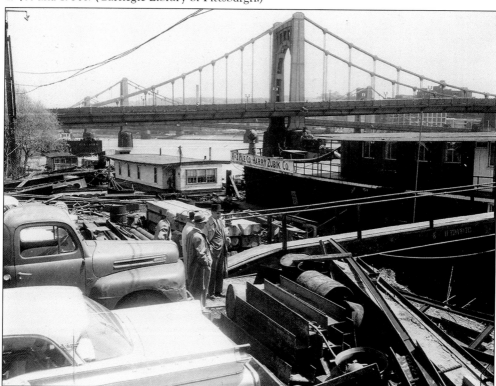

With the decline of the steel making industry in the Pittsburgh region, many businesses that depended on the industrial river traffic for their survival began to feel the economic pinch. (Carnegie Library of Pittsburgh.)

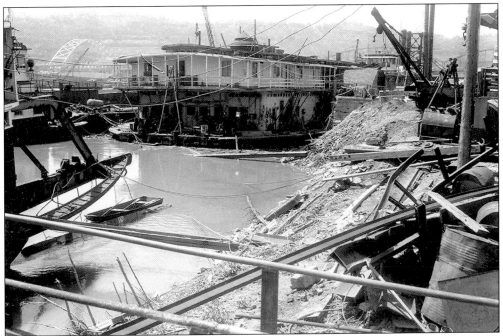

Before the days of urban renewal and redevelopment, there were places along all of Pittsburgh's rivers that became dumping grounds and junkyards for oil boat parts, rusty drums, and derelict ships. (Carnegie Library of Pittsburgh.)

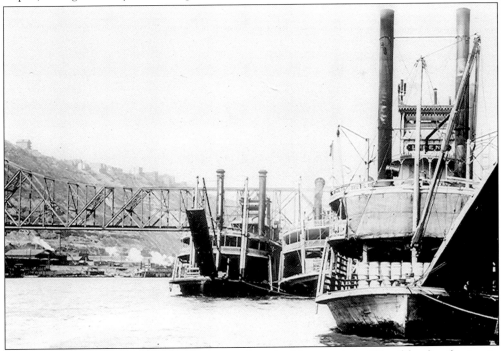

In 1845, a total of 12,000 tons of cargo arrived at the Monongahela Wharf for distribution in the Pittsburgh area. These totals did not include lumber, bricks, sand, or coal. (Carnegie Library of Pittsburgh.)

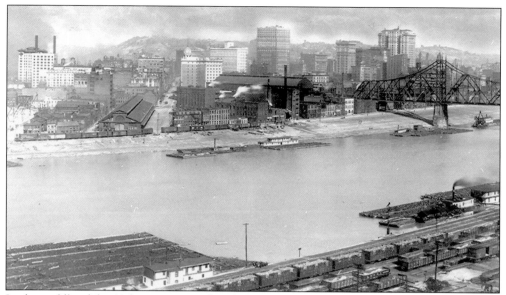

In the middle of the 19th century, Pittsburgh shipped nearly 7,000 tons of goods to cities in the east such as New York and Philadelphia. These items included glass from the numerous factories in the area and food from the H. J. Heinz Plant. (Carnegie Library of Pittsburgh.)

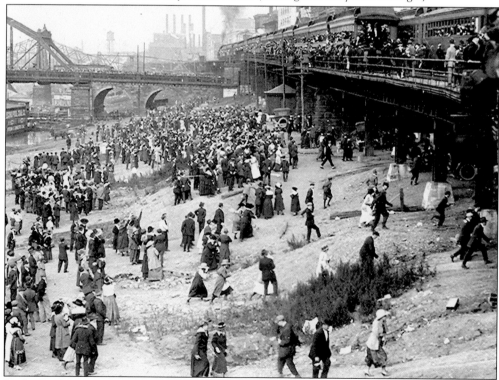

In September 1917, World War I draftees were seen off by families and loved ones at the Duquesne Way Wharf. In a four-day period, over 4,500 soldiers from Allegheny County were sent to Petersburg, Virginia, for training at Camp Lee before serving their country in Europe. (Carnegie Library of Pittsburgh.)

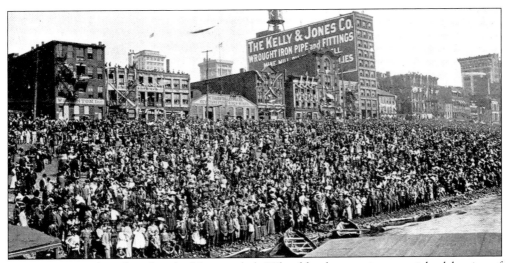

Some 3,000 people gathered at the Monongahela Wharf for the sesquicentennial celebration of Pittsburgh. One reporter noted, "As far as the eye can see, the sons and daughters of Pittsburgh come out to celebrate." (Carnegie Library of Pittsburgh.)

Since the 1920s, and prior to the construction of Pittsburgh's parking garages, more than 300 automobiles were able to park at the Monongahela Wharf everyday. Unfortunately, when the river rises, these spaces are lost, even today. (Carnegie Library of Pittsburgh.)

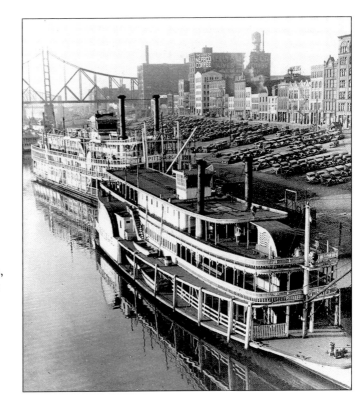

The Monongahela Wharf has a proud history with the city and its rivers. It is a place of historical importance, great accomplishments, celebrations, and firsts. The wharf hosted dignitaries including presidents and those noteworthy in entertainment and literature. Before the days of train and truck transportation, the Monongahela Wharf accepted 93 percent of the goods received into the city. (Carnegie Library of Pittsburgh.)

Six

THE POINT

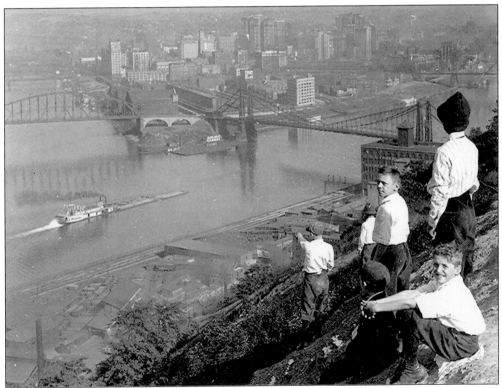

One of the most photographed sights in the Pittsburgh area has always been, and will most likely always be, the Point. The two most popular places to view the Point are the West End overlook or Mount Washington. Although the view and landscape has changed a bit over the years, Pittsburgh's Point is as closely identified with Pittsburgh as the rivers are. (Carnegie Library of Pittsburgh.)

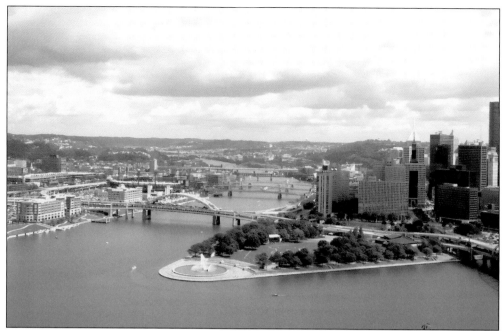

Some people, most of them not from Pittsburgh, believe that all three rivers have their origin at the Point, while others have claimed that all rivers begin elsewhere, flow to the Point, and stop. The fact is that the Point is where the Allegheny River meets the Monongahela River to form the Ohio River. (Mark Ladner.)

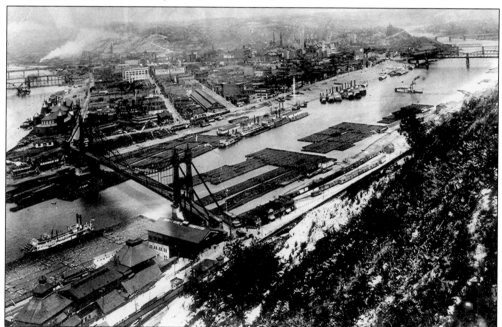

In 1910, the Point and its historic relevance to the city were considered to be "forgotten and disregarded by most Pittsburghers. Its historic and topographical significance can never be altered. It is hoped that the city will rise to its opportunity and nobly form the Point into a great monument." (Carnegie Library of Pittsburgh.)

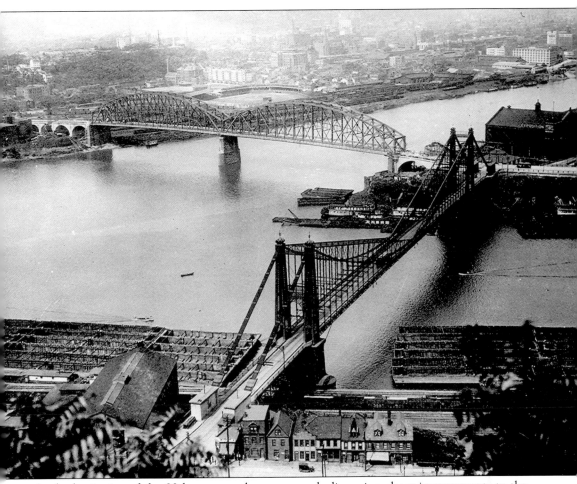

At the beginning of the 20th century, there was much discussion about improvements to the Point. Talk was already underway for improvements to both waterfronts along the Monongahela and Allegheny Rivers in the city. It was suggested that if improvements were made for public enjoyment to the waterfronts that it should extend to where both fronts meet at the Point. (Carnegie Library of Pittsburgh.)

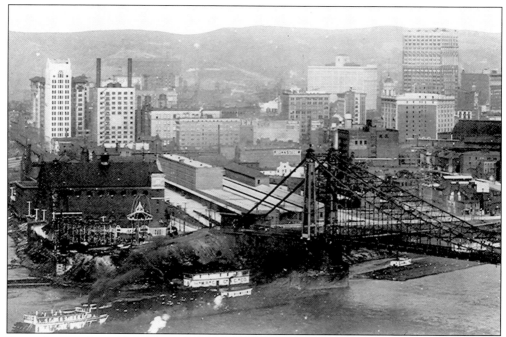

Somewhere in the midst of the warehouses, train tracks, and old buildings stands the Fort Pitt Block House. As development at the Point seemed to come and go over 200 years, the Fort Pitt Block House remained constant. (Carnegie Library of Pittsburgh.)

This photograph, taken in 1906, shows First Street at the Point. This area included not only exhibition buildings and warehouses but also tenements where multiple families lived. This was also the area most prone to flooding. (Carnegie Library of Pittsburgh.)

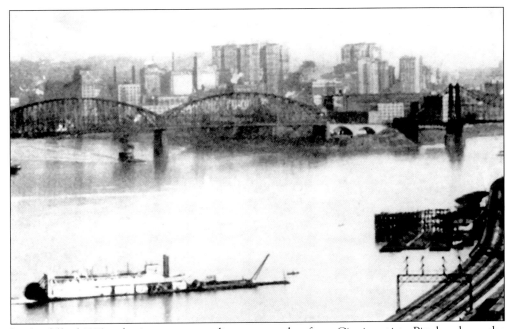

In the fall of 1873, a businessman traveling on a packet from Cincinnati to Pittsburgh on the Ohio River saw the city in the distance. As the ship reached the confluence, he marveled at the sprawling metropolis and writing in his journal remarked that "Pittsburgh is on the cusp of greatness." (Carnegie Library of Pittsburgh.)

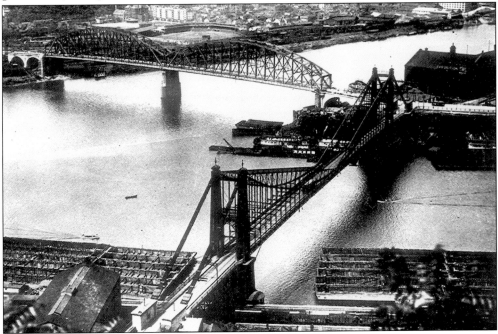

After the French threat was eliminated, the land that would eventually become known as Pittsburgh's Point was sold in 1772 to William Thompson and Alexander Ross for 50 pounds in New York currency. This property included the buildings as well was the fort. Some 130 years later, that land was developed into what is seen here. (Carnegie Library of Pittsburgh.)

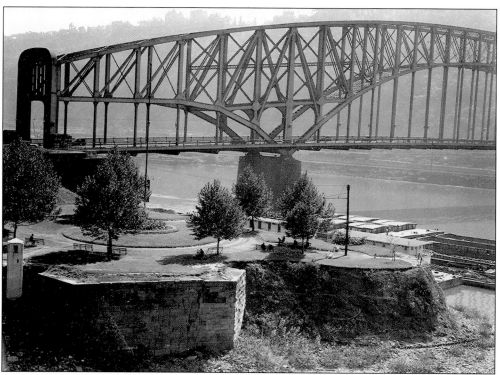

In a small park just above the Fort Pitt Block House, a few people can be seen relaxing in the shadow of the Point Bridge in this 1930 photograph. (Carnegie Library of Pittsburgh.)

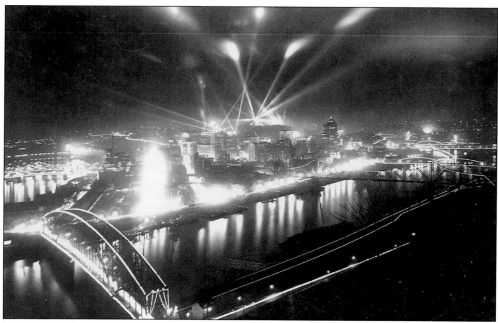

Pittsburgh lights up as it celebrates the completion of the nine-foot Ohio River channel in 1929. (Carnegie Library of Pittsburgh.)

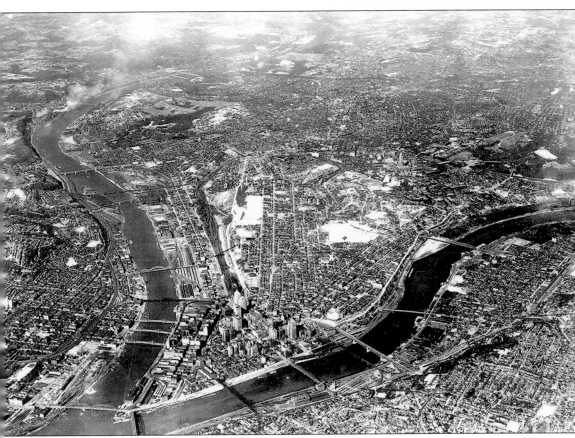

When describing the Point, a writer once penned, "Here is the spot where the Ohio River has its birth. Here was built the fort which broke the peace of Europe and around which turned the frontier struggles of the war that gave America to the English speaking race. It is here that all of the inspiring associations of the city are chiefly located. Poetically, this spot, at the meeting of the rivers, stands for Pittsburgh." (Carnegie Library of Pittsburgh.)

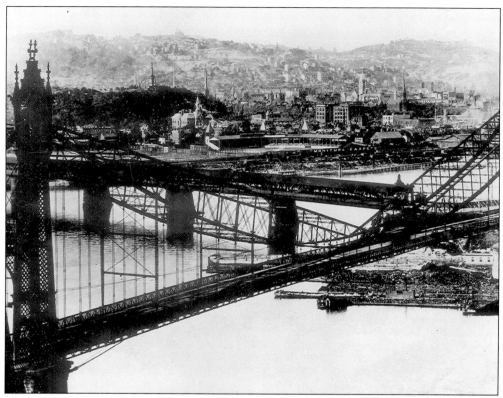

On a typical day in 1896, before smog control, the Point and Manchester Bridges are seen here under a cloud of thick industrial smoke. In the background are the North Side and Monument Hill. (Carnegie Library of Pittsburgh.)

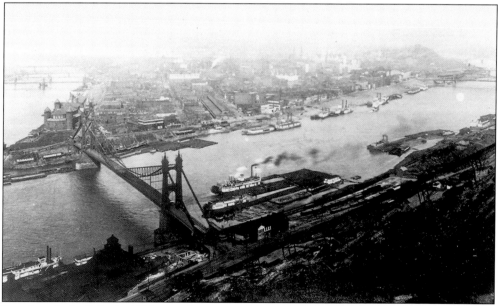

Seen here is the Point in 1890 as towboats round the tip of Pittsburgh from the Allegheny to the Monongahela River. (Carnegie Library of Pittsburgh.)

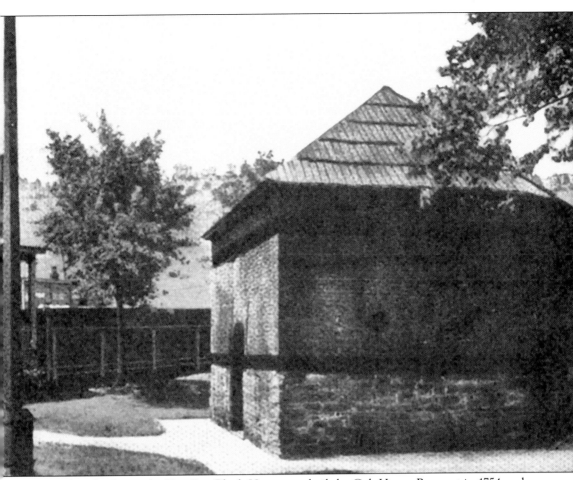

Located at the Point, the Fort Pitt Block House was built by Col. Henry Bouquet in 1754 and remains today as the oldest historic building in the region. Although small in size, it is a strong structure that has withstood time, the elements, numerous Pittsburgh floods, and industrial development at its very doorstep. The Fort Pitt Block House is owned and operated by the Daughters of the American Revolution and stands as a testament to the strength and endurance shown by those who conquered the wilderness of Western Pennsylvania. (Carnegie Library of Pittsburgh.)

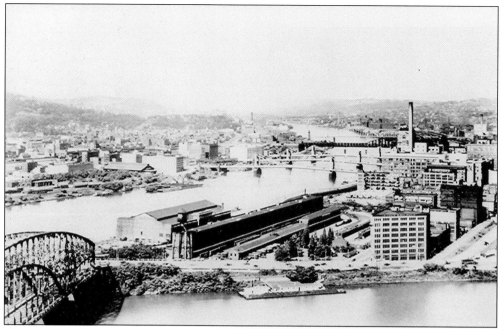

During the 1940s, there was an idea to form a committee with the purpose of reclaiming the land at the Point. Within 10 years, the Point Park Committee of the Allegheny Conference was established, and by 1950, most of the land was purchased. (Carnegie Library of Pittsburgh.)

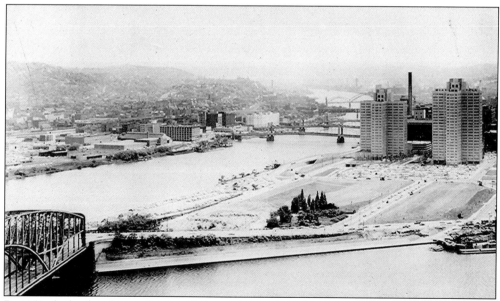

By 1952, the land at the confluence of the rivers was cleared with preparations underway to build a state park. The only piece of property not bought by the committees was the land occupied by the historic Fort Pitt Block House. (Carnegie Library of Pittsburgh.)

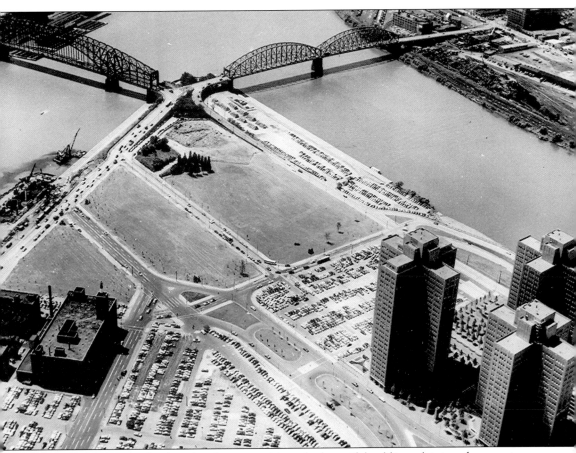

When the land was redeveloped and converted into the beautiful public park it is today, a major part of the city's First Ward's streets was lost along with many businesses and homes. These streets included Exchange Street, Water Street, Bell Way, Duquesne Way, Bell's Alley, Point Alley, Chancery Lane, Decatur Street, Fort Street, Short Street, Evans Alley, Ferry Street, and Redoubt Alley. (Carnegie Library of Pittsburgh.)

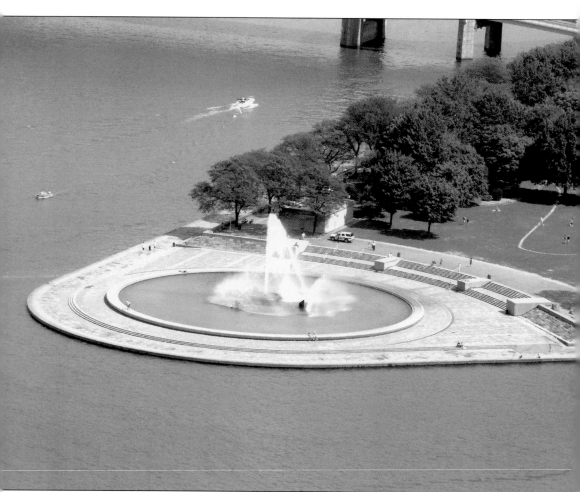

The fountain at the Point has long been at the center of a local debate. Since it was built in the early 1970s, many people believe that its water source is an "underground river." Flowing much like the Monongahela or Ohio, a lot of Pittsburghers think that the river is contained in a vast underground cavern that is as easy to navigate as its aboveground counterparts. In reality, the most common scientific theory is that Pittsburgh's "Fourth River" is actually an aquifer, which is a layer of gravel and sand that stores water underground. This water is then pumped up to feed the fountain. (Mark Ladner.)

Seven

ANGRY WATERS

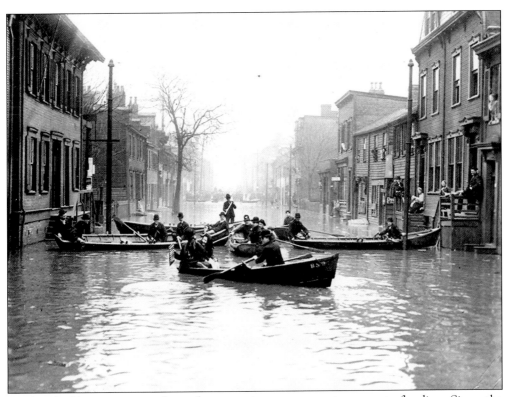

Pittsburgh, like many cities located near major waterways, is prone to flooding. Since the establishment of the first settlement at the forks of the Ohio, high water has been a problem for those who work and live near the rivers. Since 1810, a total of 11 out of 17 floods recorded in Pittsburgh occurred during the months of February, March, or April, with two of the most devastating to life and property occurring almost exactly 29 years apart—March 15, 1907, and March 16, 1936. (Carnegie Library of Pittsburgh.)

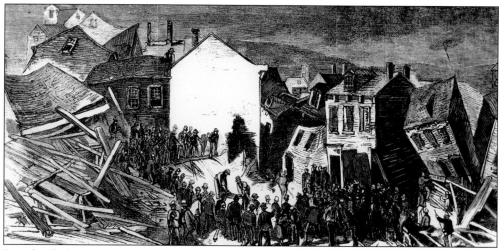

Just after dark on the night of July 26, 1874, a thunderstorm like none seen in recent history brought torrential rains to the city of Pittsburgh. An account of the devastation noted, "The residents of Wood's Run and Spring Garden Run had no warning." (Carnegie Library of Pittsburgh.)

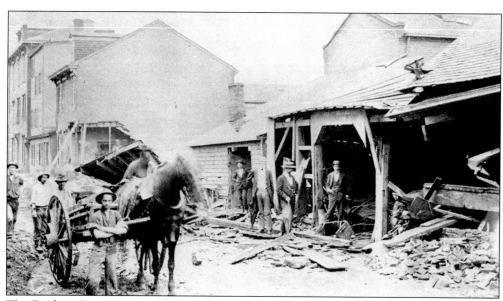

The *Pittsburg Post* newspaper described the scene as buildings, their contents, human beings, animals of every description, mountains of clay, sand and gravel, street lamps, and fences all part of the raging torrent. (Carnegie Library of Pittsburgh.)

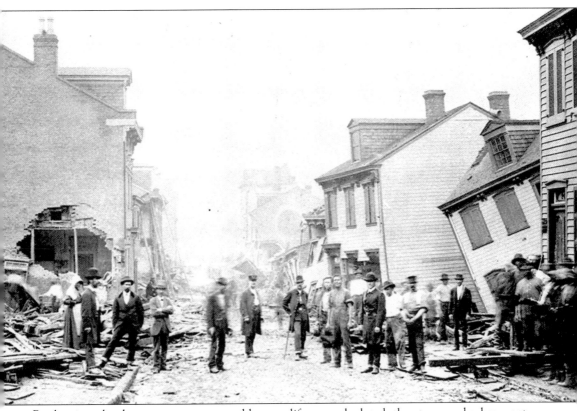

By the time the damage to property and human life was calculated, the storm and subsequent flood left 150 dead, with half of those losing their lives outside the city of Pittsburgh. Property damage was estimated at over $3 million, with extensive loss of residences, businesses, and livestock. Much of the loss was structures that were built precariously on the steep hillsides. (Carnegie Library of Pittsburgh.)

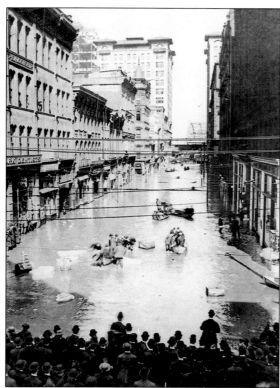

On March 15, 1907, melting snow and heavy rains brought the river's stage to over 36.5 feet. As the water rose quickly, it took the residents of Pittsburgh by surprise as many were stranded and needed to be rescued, as seen here along Sixth Street. (Carnegie Library of Pittsburgh.)

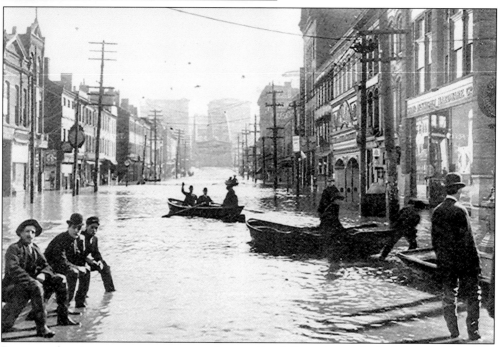

Boats on the city streets were commonplace as Good Samaritans plucked those unfortunate enough to get caught in the frigid waters. This view is of Federal Street on the North Side looking toward downtown. (Carnegie Library of Pittsburgh.)

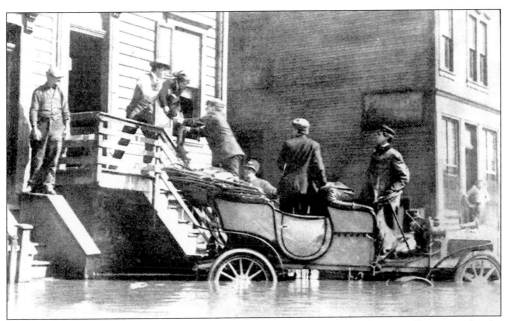

Although many motorcars were used to get around Pittsburgh's flooded streets, they proved to be no match for the draft horse pulling a wagon. (Carnegie Library of Pittsburgh.)

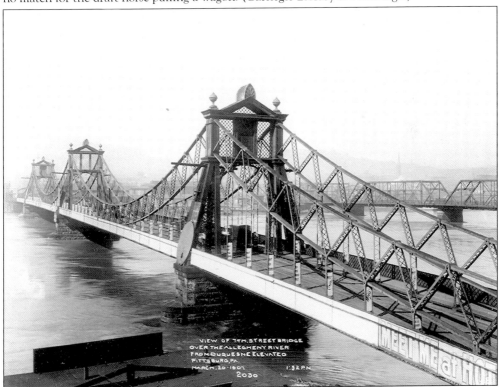

During the flood, river traffic came to a virtual halt as most of the city's docks and landings were either underwater or had been washed away. The economic loss to local merchants was heavy due to the loss of goods in stored warehouses along the rivers. (Carnegie Library of Pittsburgh.)

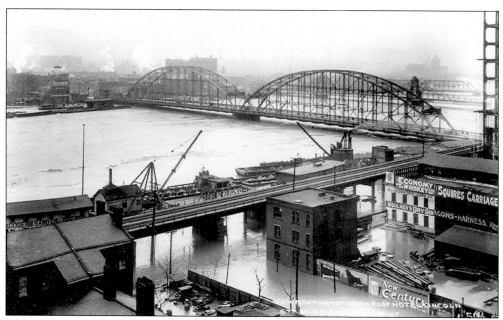

Although the loss of life in the 1907 flood was limited to 12, the economic cost was over $5 million. These losses were not just limited to damage but also unemployment as many businesses, factories, and foundries in the Pittsburgh area were underwater or closed from damage. (Carnegie Library of Pittsburgh.)

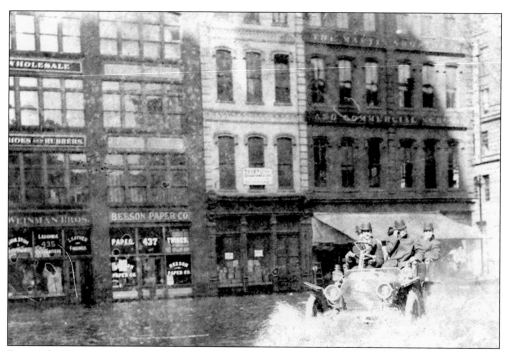

For weeks, businesses in downtown Pittsburgh were closed due to the destruction brought by high floodwaters. In many cases, businesses never reopened after being unable to recover losses. (Carnegie Library of Pittsburgh.)

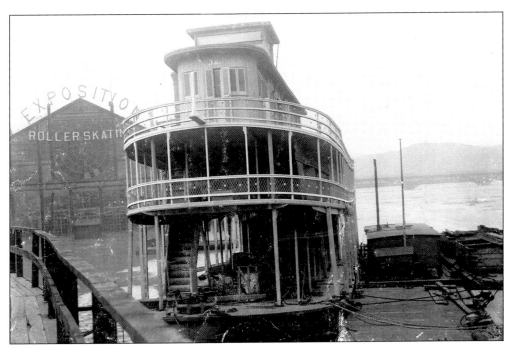

This boat, like many that wound up on dry land after the waters receded, had to be reacquainted with the river. In some places in the city, flood cleanup took up to 14 months. (Carnegie Library of Pittsburgh.)

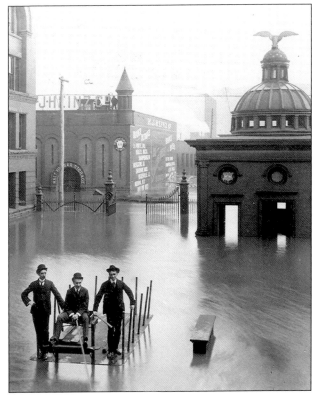

In this picture of the 1907 flood, the main entrance yard at the H. J. Heinz Plant is underwater as was the malt vinegar storage building as seen on the top left. The men in the photograph are standing on a wagon that is usually pulled by horses. (Carnegie Library of Pittsburgh.)

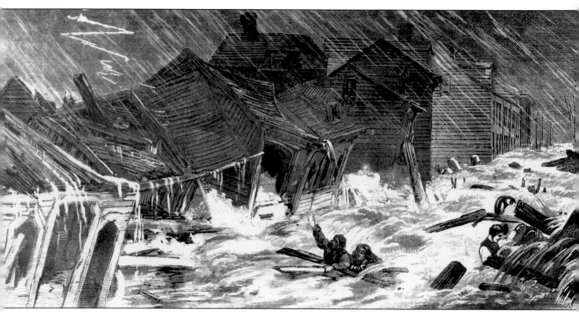
Being the tight-knit town that Pittsburgh has always been known as, the residents of the city worked together as neighbor helped neighbor rebuild their community. Little did Pittsburgh know that yet another devastating flood would hit exactly 29 years later. (Carnegie Library of Pittsburgh.)

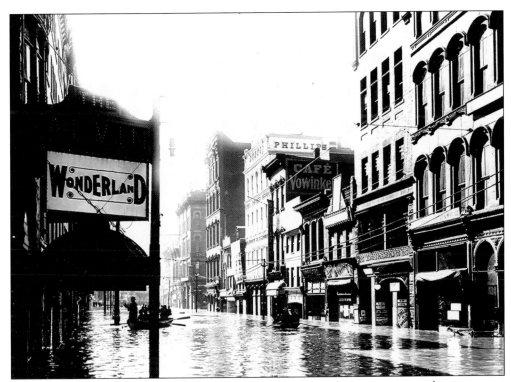

Although the flood of 1907 was the biggest news of the time, there were many other important events that year, including the dedication of the Carnegie Institute of Technology, now Carnegie Mellon University. (Carnegie Library of Pittsburgh.)

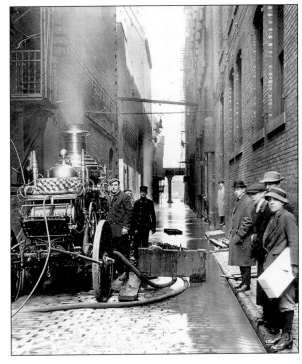

In January 1913, the rivers of Pittsburgh crested at 31 feet and the city was to endure yet another flood. Although not as damaging as the one six years prior, water had to be pumped from the streets by the fire department. (Carnegie Library of Pittsburgh.)

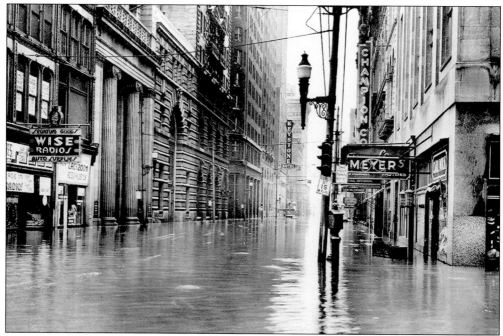

On March 17, 1936, floodwaters again engulfed the streets of Pittsburgh. By the next day, the waters crested at 46 feet, the highest in the city's history. This became known as the St. Patrick's Day Flood. (Carnegie Library of Pittsburgh.)

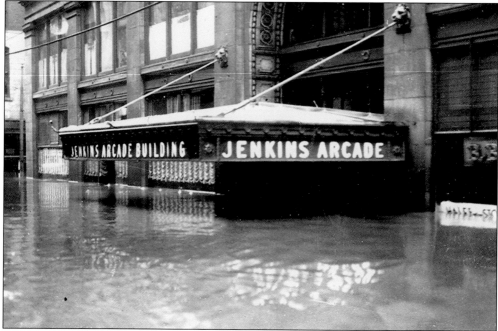

Up-to-date information on the flood was scarce, so curious on-lookers attempted to see the city's devastation first hand but were turned away by police. Communications were hampered as power was out due to damaged electrical stations, and many highways and roadways were blocked. (Carnegie Library of Pittsburgh.)

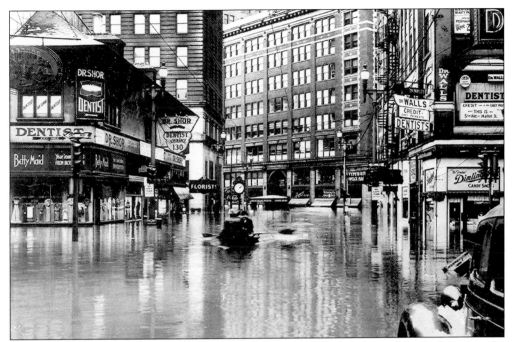

Here at the intersection of Fifth Avenue and Market Street, looking toward the Jenkins Arcade, only the tops of trolleys and cars were visible as the water reached 20 feet deep in some places. (Carnegie Library of Pittsburgh.)

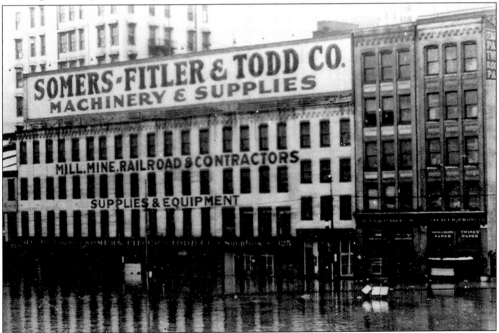

The flood brought devastation to not only Pittsburgh, but damaged other communities such as Johnstown, Kittanning, Wheeling, Greensburg, Vandergrift, Apollo, and Tarentum. All river towns along the Monongahela, Ohio, and Allegheny Rivers in Pennsylvania, Ohio, and West Virginia were affected. (Carnegie Library of Pittsburgh.)

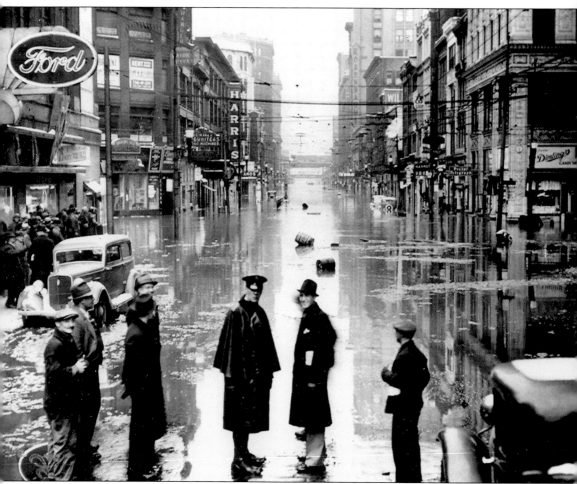

The *Pittsburgh Sun-Telegraph* newspaper reported, "Receding Waters Reveal Vast Desolation." It seemed to be a cruel irony that, while the rivers flooded the city and surrounding communities, the most critical problem that affected the people of the region was the lack of good drinking water. In the South Hills alone, more than 200,000 people were without water, and in the Ross station of the water bureau, the plant machinery had to be disassembled and dried out. (Carnegie Library of Pittsburgh.)

From all over Pittsburgh, those who could help their neighbors in need came to give their assistance. They included police and fire personnel, the Red Cross, troops from the National Guard, the religious community, and the Boy Scouts. All volunteered to work day and night until the task of cleaning up was done. (Carnegie Library of Pittsburgh.)

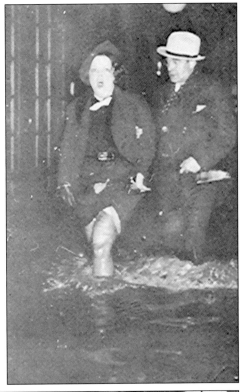

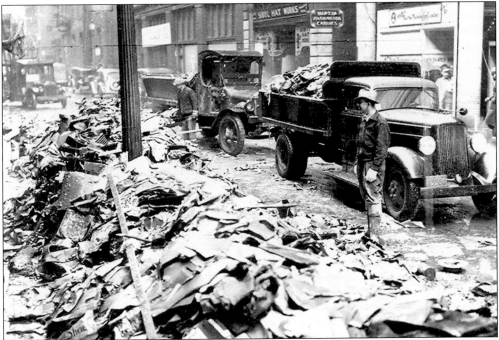

As seen here, thousands of workmen descended on downtown Pittsburgh and the Golden Triangle. Many worked 24 hours a day clearing streets and roads, removing tons of debris. (Carnegie Library of Pittsburgh.)

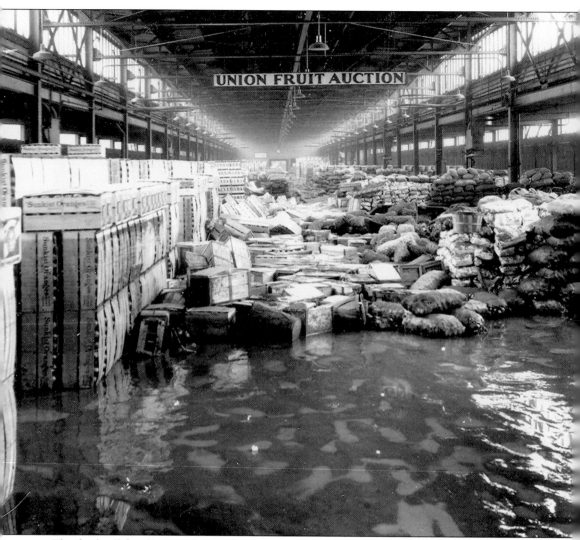

The final toll for the St. Patrick's Day Flood of 1936 was 74 dead, more than 300 injured, and 50,000 left homeless. Clean up took months as debris had to be removed from every street, roadway, and alley throughout the city of Pittsburgh and beyond. The effects of the high waters were felt throughout the region as entire river communities were either heavily damaged or completely wiped out. As many businesses and industries were affected, local newspapers reported, "Uncounted thousands out of work." (Carnegie Library of Pittsburgh.)

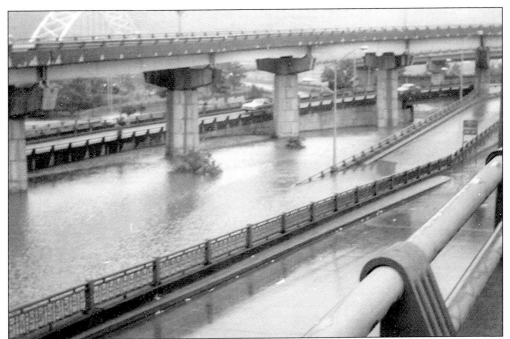

On June 23, 1972, Hurricane Agnes, recently downgraded to a tropical storm, parked over the Allegheny River Valley and dumped 11 inches of rain on the region. The end result was the floodwaters cresting at 36 feet in Pittsburgh, 11 feet above flood stage. (Carnegie Library of Pittsburgh.)

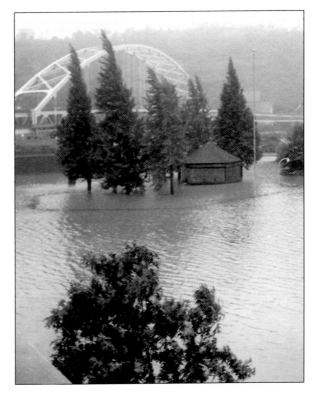

Shown here, the Fort Pitt Museum and Block House are located right at the Point. Historical artifacts can not be stored within their facility, as the buildings are prone to flooding. (Carnegie Library of Pittsburgh.)

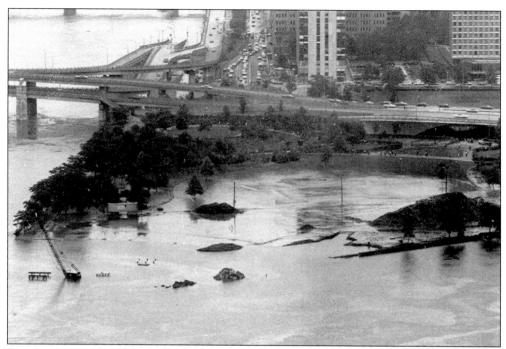

The floodwaters engulfed the Point up to the Pittsburgh Hilton Hotel at Gateway Center. On the lower left of the photograph, a submerged crane that was constructing the fountain at Point State Park can be seen. (Carnegie Library of Pittsburgh.)

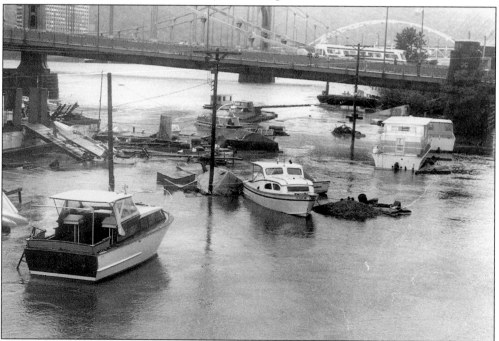

The flood wave that originated mainly on the Allegheny River moved through Pittsburgh and down the Ohio River heavily damaging the towns of Coraopolis, McKees Rocks, and Wheeling, West Virginia. (Carnegie Library of Pittsburgh.)

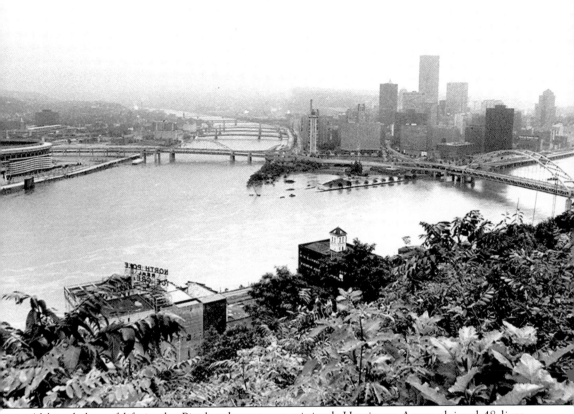

Although loss of life in the Pittsburgh area was minimal, Hurricane Agnes claimed 48 lives statewide and caused over $2 billion in damage. The rain and subsequent flood of 1972 left 220,000 Pennsylvanians homeless—34,000 in the Pittsburgh region. The flooding completely destroyed 67,000 homes and 2,800 businesses throughout the state, causing President Nixon to name Pennsylvania as well as Virginia and New York major disaster areas. (Carnegie Library of Pittsburgh.)

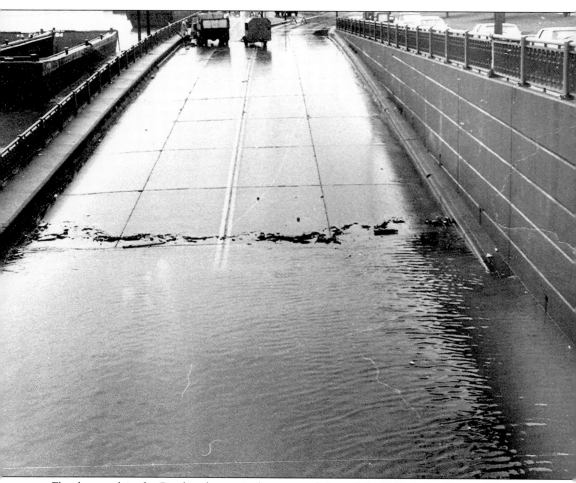

Flood control in the Pittsburgh area is the responsibility of the U.S. Army Corps of Engineers. After the St. Patrick's Day Flood of 1936, the Army Corps changed its primary goal of improving navigation on Pittsburgh's rivers to that of flood control in the region. No matter what precautions are taken to control the rising of waters during the spring thaw or heavy rains, flooding in Pittsburgh and its surrounding communities is a fact of life for those who live and work on or near the rivers. (Carnegie Library of Pittsburgh.)

Eight

LOCKS AND DAMS

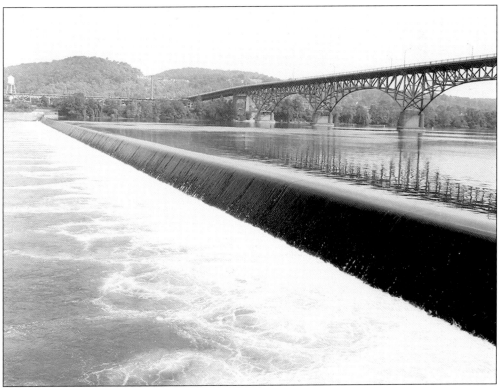

In 1929, the U.S. Army Corps of Engineers completed the multi-year project of the canalization of Pittsburgh's rivers. Prior to its completion, riverboat traffic was at the mercy of the rains and spring thaw to raise the water level enough to support the heavy boats. Some of the river levels recorded were as shallow as 12 inches. After the dams were built, backwaters known as "pools" brought water levels to a consistent nine feet on all rivers. Today it is the responsibility of the Army Corps to monitor the changing river levels and oversee boating on the rivers, both commercial and pleasure. The Pittsburgh District operates and maintains 23 locks and dams on the Allegheny, Ohio, and Monongahela Rivers. (Carnegie Library of Pittsburgh.)

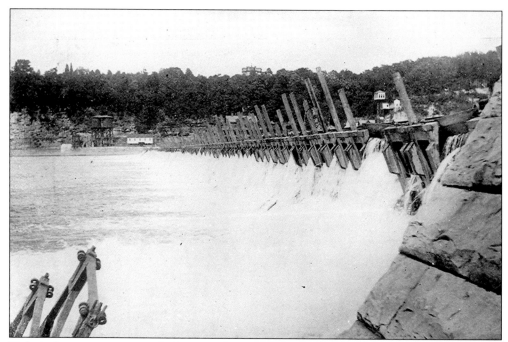

Today's dams are constructed of iron and concrete, but in the early days, dams were made of large wooden structures called wickets. They were timbers fastened together, which could be raised and lowered to regulate river pool levels. (Carnegie Library of Pittsburgh.)

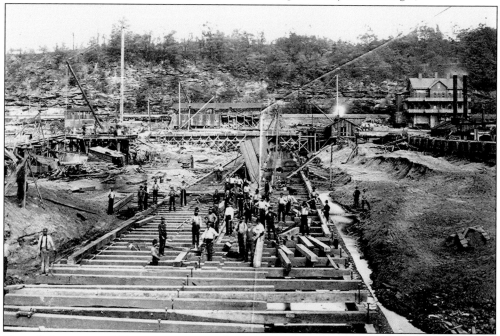

One of the most ambitious projects was the construction of a dam located in Bellevue just six miles up the Allegheny River from Pittsburgh's Point. In 1878, the government purchased land from the Davis family and began construction known as the Davis Island Dam. (Carnegie Library of Pittsburgh.)

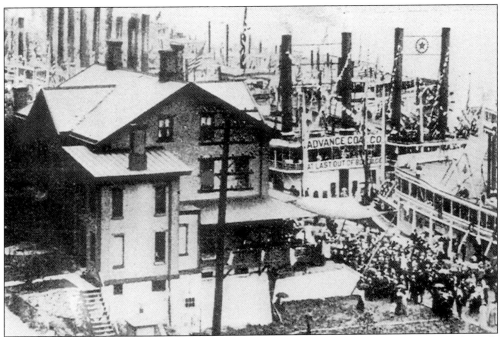

The dam at Davis Island opened in 1885 at a cost of $860,000. The span was 12 feet high, with the lock measuring 110 feet wide and 600 feet long, a standard even today. It was the first dam constructed on the Ohio River but was later replaced by the Emsworth Dam. (Carnegie Library of Pittsburgh.)

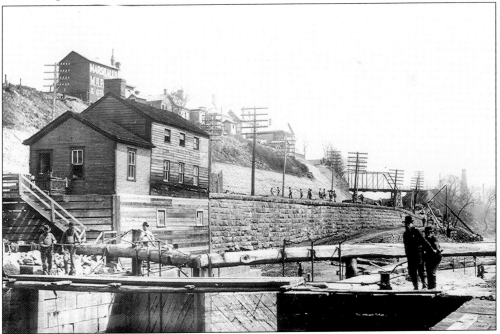

In the 1800s, locks and dams were built before the advent of earth-moving machinery using livestock to move heavy stone work and human muscle to move the soil. (Carnegie Library of Pittsburgh.)

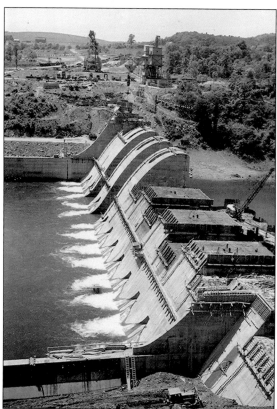

Rivers and tributaries that are upstream of Pittsburgh's rivers dictate the water levels here. Many of Pittsburgh's floods were due to high water levels from rains elsewhere. Seen here is the construction of the Conemaugh River Reservoir. Installed to control flooding, the reservoir sits on the Conemaugh River, which is a tributary of the Allegheny River. (Carnegie Library of Pittsburgh.)

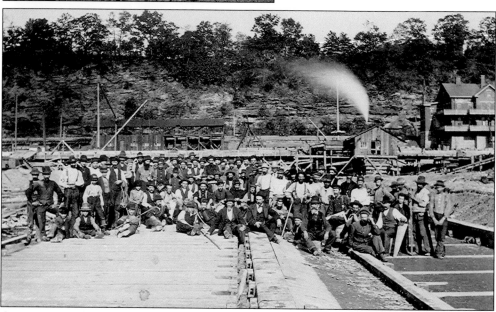

Construction of the dams and locks in the late 1800s and early 1900s demanded skilled labor. Workers in the trades such as stone masons, carpenters, bricklayers, and iron workers were employed. The work was hard, but as one laborer put it, "steady work is good work." (Carnegie Library of Pittsburgh.)

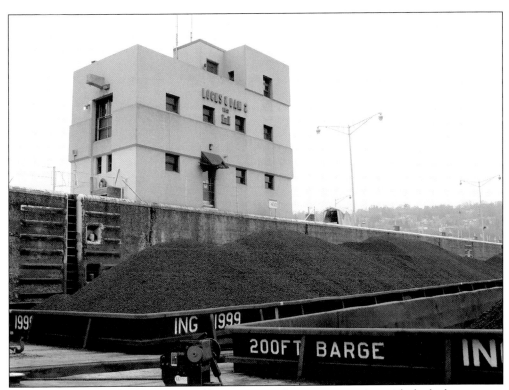

While passing through, all commercial boats are in radio communication with the lock operators. Boat pilots also follow traffic light signals and air horn signals. One horn blast is the signal for a boat to enter the lock, while two blasts is the signal to leave the lock. (Daniel J. Burns.)

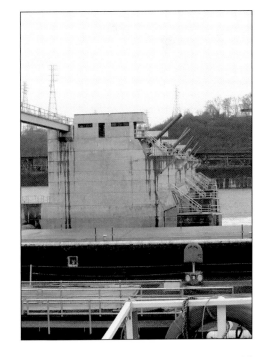

The Pittsburgh district of the Army Corps spans over 26,000 square miles and includes parts of Pennsylvania, New York, Maryland, and West Virginia. It includes not only dams and locks but numerous reservoirs and flood control projects. (Daniel J. Burns.)

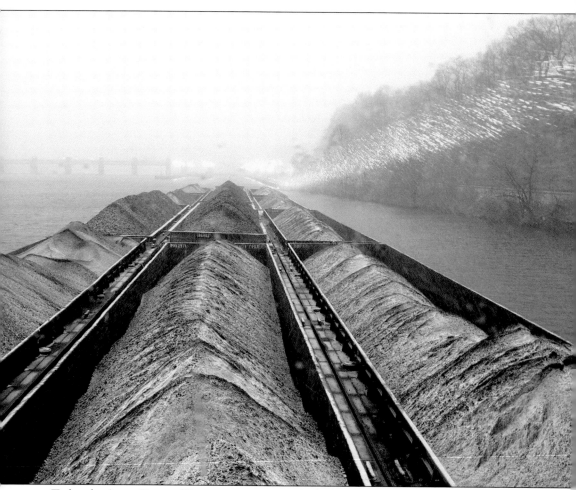

Today the Army Corps of Engineers operates eight locks and dams on the Allegheny River that enable river navigation from East Brady, Pennsylvania, to Pittsburgh; nine locks and dams on the Monongahela River from Fairmont, West Virginia, to Pittsburgh; and six locks and dams on the Ohio River. This provides for boat navigation from Pittsburgh to New Martinsville, West Virginia. (Daniel J. Burns.)

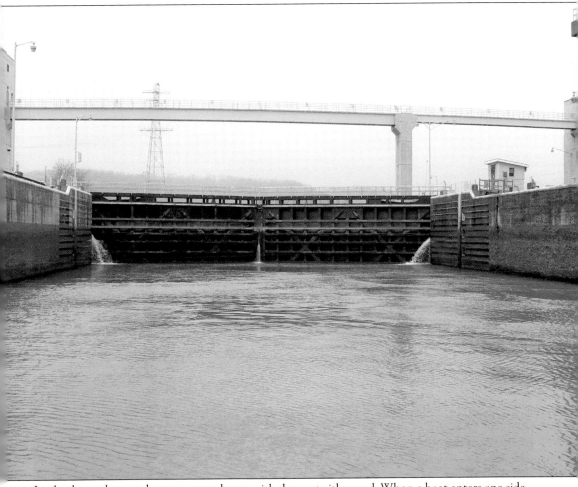

Locks themselves are large concrete boxes with doors at either end. When a boat enters one side, the doors close and water is either raised or lowered depending on the boat's direction of travel. The opposite doors are then opened, and the boat is now at the new level of the river below or above the dam. There are no pumps used to raise or lower the water levels in the lock chamber as it is all achieved by gravity. (Daniel J. Burns.)

"Locking through" is the term when a boat is passing through a lock. Each lock has operators who are employed by the Army Corps and act as the traffic cops of the river, having the same authority over boats. The federal government has dictated the priority that river vessels have when passing through locks. They are, in order, military vessels, boats carrying mail, commercial boats, and recreational vessels. There is no charge for recreational or pleasure boats to use the locks. However, commercial vessels pay a 15 percent excise tax on their fuel. These monies go toward river projects, maintenance, and upkeep. (Daniel J. Burns.)

Nine

YESTERDAY'S INDUSTRY

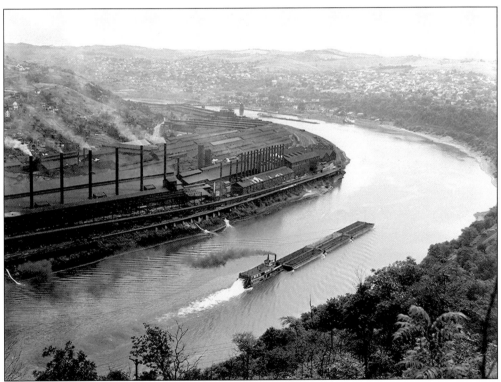

By the early 1900s, Pittsburgh was dubbed the busiest city in the world as it produced 32 percent of the entire United States product. Pittsburgh steel production alone accounted for 47 percent of all steel manufactured in the United States, and about 15 percent worldwide. Between the steel production facilities, the glass-making furnaces, the bridge-building industry, and many other industrial manufacturing facilities in the area, it is little wonder that Pittsburgh was once called "Hell with the lid off." (Carnegie Library of Pittsburgh.)

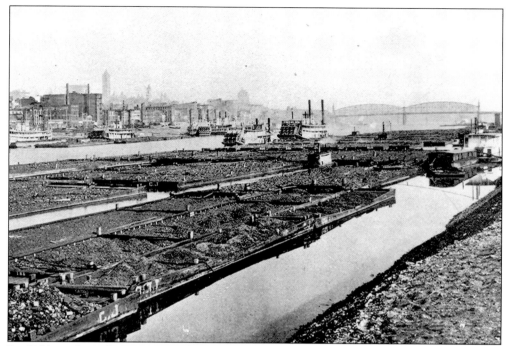

By 1904, coal production in Pittsburgh made up 36 million tons annually. This accounted for nearly 12 percent of the nation's total coal production. This coal was moved on the rivers 24 hours a day, seven days a week. (Carnegie Library of Pittsburgh.)

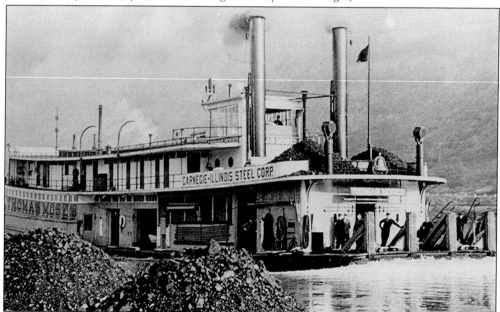

According to the Washington Bureau of Navigation, between 1812 and 1826, there were 48 steamboats built in the Pittsburgh area. The towns that were shipbuilding communities included Pittsburgh, Allegheny City, Beaver, Belle Vernon, Brownsville, California, Elizabeth, McKeesport, Industry, Kittanning, Lawrenceville, Masontown, Monongahela, West Newton, and West Elizabeth. (Carnegie Library of Pittsburgh.)

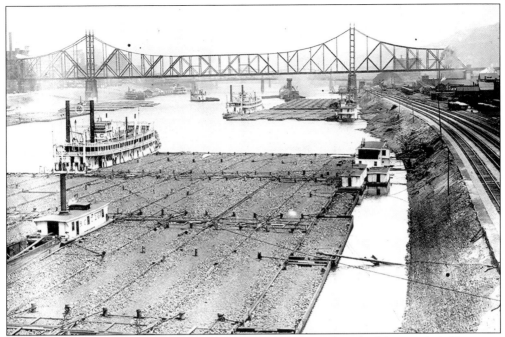

According to a bulletin published in 1920, the tonnage shipped on the Monongahela River was greater that of the Panama and Suez Canals combined. The tonnage for the Monongahela River was 16 million tons; the Panama Canal saw 7.5 million tons, and the Suez Canal 7.8 million tons. (Carnegie Library of Pittsburgh.)

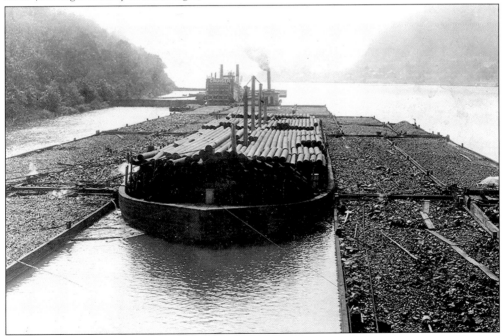

In the early days of barge transportation, many of the men who worked on the rivers had little or no formal education. They learned all they needed to know on the river. The work was hard and dangerous, but most did not know how to do anything else. (Carnegie Library of Pittsburgh.)

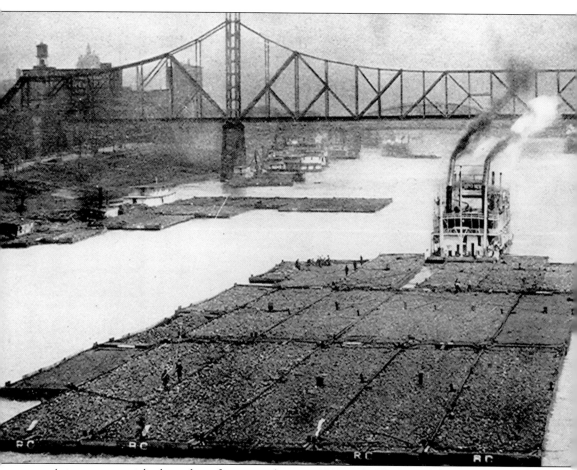

A newspaper article about the influenza epidemic in 1918 read, "Flu Retards Production and then came the black death to the valley. The result was worse than all others combined—hundreds of experienced coal miners died and with the already scarcity of unskilled labor, conditions became acute. Yet despite all setbacks, the district was only 20,000 tons behind last year which, among the river men, was considered a record-breaker." Although many died during the pandemic of 1918, the affect on the river trade was minimal, perhaps due to their limited exposure to those on the bank. (Carnegie Library of Pittsburgh.)

Most large industries such as Jones and Laughlin Steel, the Dravo Corporation, and the Carnegie-Illinois Steel Company owned and operated their own boats like the one pictured here. The pilots and deckhands were also under the employment of those companies. (Carnegie Library of Pittsburgh.)

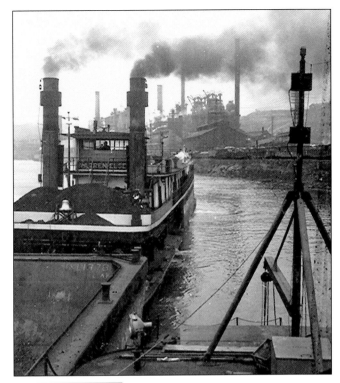

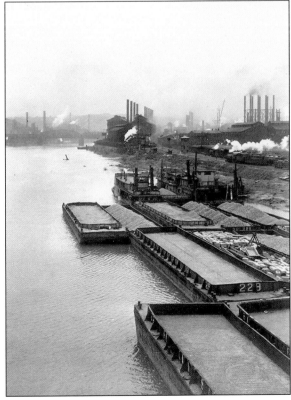

This photograph, taken in 1930, shows barges being unloaded near one of the many steel manufacturing plants along the Monongahela River. (Carnegie Library of Pittsburgh.)

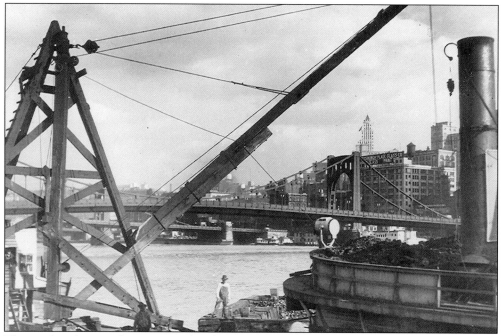

The word towboat applies to a vessel with a squared-off head or front and knees, designed primarily for facing a tow, or group of barges, or handling them as an entire unit. (Carnegie Library of Pittsburgh.)

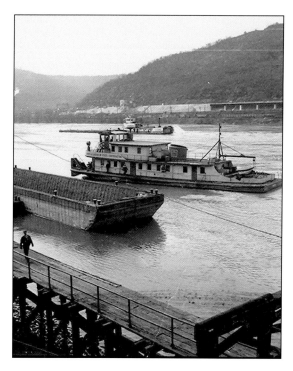

As times changed, so did the methods in which the grand boats of the rivers pushed their cargos on the water. The diesel and electric-driven turbines replaced the steam engine, and the propeller replaced the paddle wheel. (Carnegie Library of Pittsburgh.)

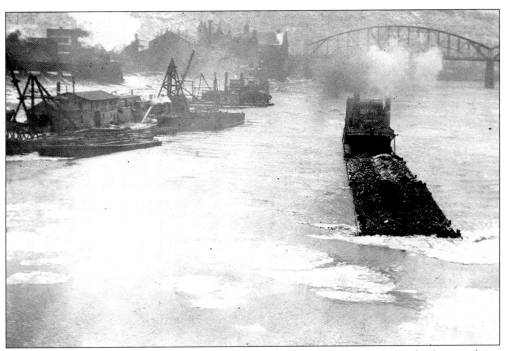

In the early days of river traffic, there were about 4,000 to 5,000 barrels of salt sent down the Allegheny River annually. At $9 per barrel, this equaled about $40,000 in just this one commodity. In addition to salt, the Allegheny saw approximately three million board feet of lumber floated down to Pittsburgh as well. (Carnegie Library of Pittsburgh.)

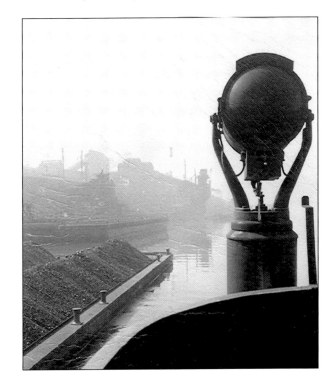

In the days before assisted river navigation, boat captains were men who knew 3,000 miles of rivers by memory. Their names include Harry Black, T. C. Poe, Warren Elsey, and Ezra Young, son of Samuel Young. (Carnegie Library of Pittsburgh.)

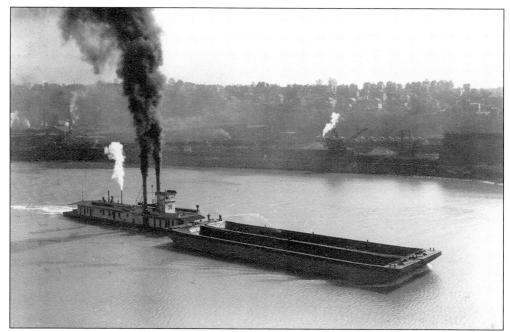

Pittsburgh's reputation as the Smoky City was evident through its industrial age due to its steel mills, foundries, and its riverboats. There were many days that the smoke blocked out the sun to the extent that a 3:00 p.m. street scene looked as if it were 3:00 a.m. (Carnegie Library of Pittsburgh.)

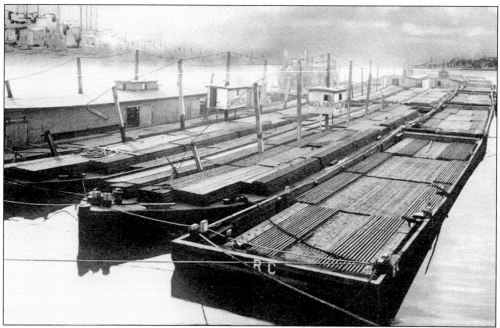

Pictured here are barges loaded with steel rails manufactured by the Carnegie Steel Duquesne Plant. These rails were destined to play an integral role in America's expansion to the west. Once again, the most efficient way to get them to their destination was by riverboat. (Carnegie Library of Pittsburgh.)

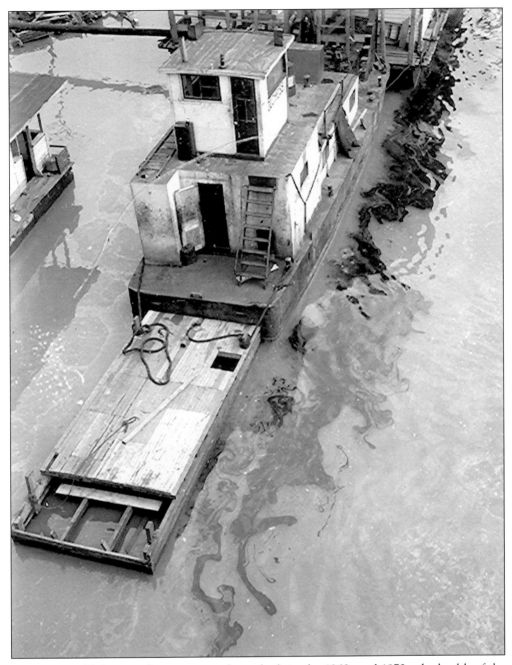

Until the establishment of environmental standards in the 1960s and 1970s, the health of the rivers themselves was rarely, if ever, a concern to those who worked on them. Oil slicks, like the one shown here, were commonplace. (Carnegie Library of Pittsburgh.)

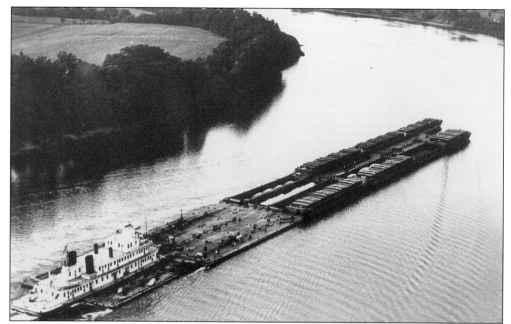

By the 1960s, Pittsburgh's manufacturing giants included U.S. Steel, Consolidation Coal, H. J. Heinz, Jones and Laughlin Steel, Westinghouse, Koppers, Dravo Corporation, Westinghouse Air Brake, Duquesne Light, ALCOA, Pittsburgh Plate Glass, Mesta Machine, Allegheny Ludlum Steel, and Pittsburgh Steel. (Carnegie Library of Pittsburgh.)

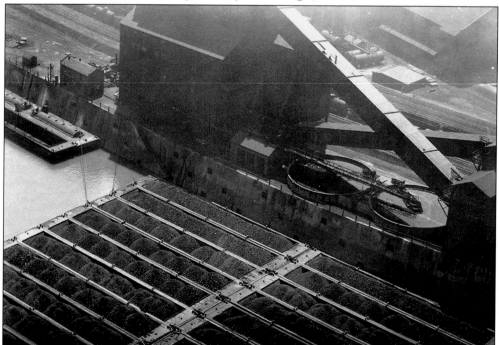

Most of the steel used in both World Wars I and II was produced in Pittsburgh's Monongahela Valley. Shown here are coal barges and the conveyor at the Carnegie-Illinois Steel Plant in Clairton in 1949. (Carnegie Library of Pittsburgh.)

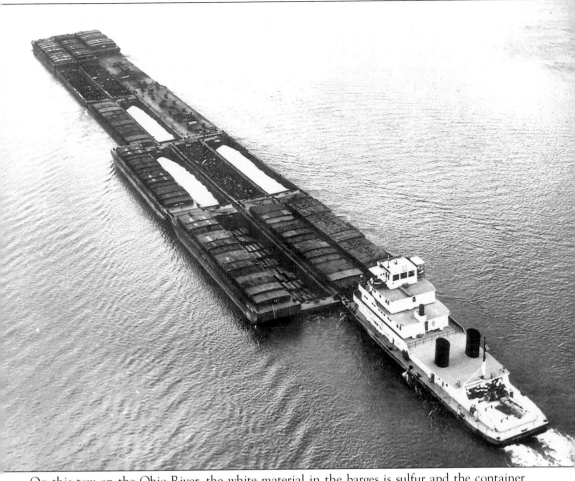

On this tow on the Ohio River, the white material in the barges is sulfur and the container barges are filled with fuel oil. (Carnegie Library of Pittsburgh.)

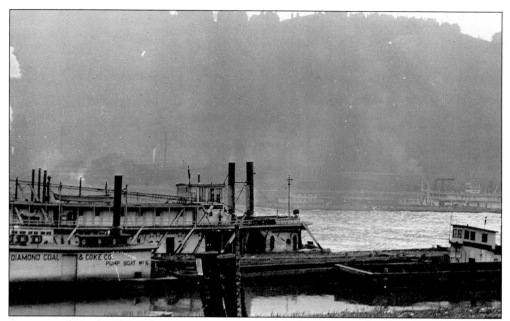

As a part of Pittsburgh's industry, many companies in the city were frequent shippers of goods throughout the country via the rivers. These companies included wholesale grocers, glass manufacturers and distributors, pig iron brokers, tea and coffee brokers, and makers of cotton goods. (Carnegie Library of Pittsburgh.)

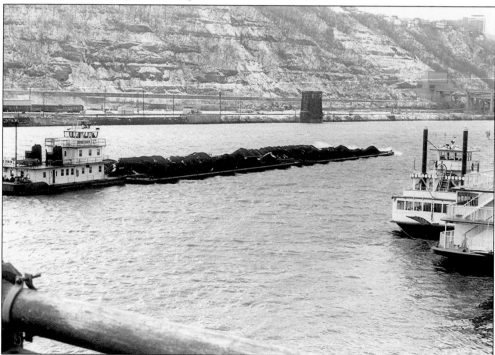

In May 1923, the Jones and Laughlin Steel Corporation shipped 8,000 tons of steel on the Ohio River from Pittsburgh to points south, including Louisville, St. Louis, and Memphis. This steel shipment was a record tonnage spread out over nine barges. (Carnegie Library of Pittsburgh.)

110

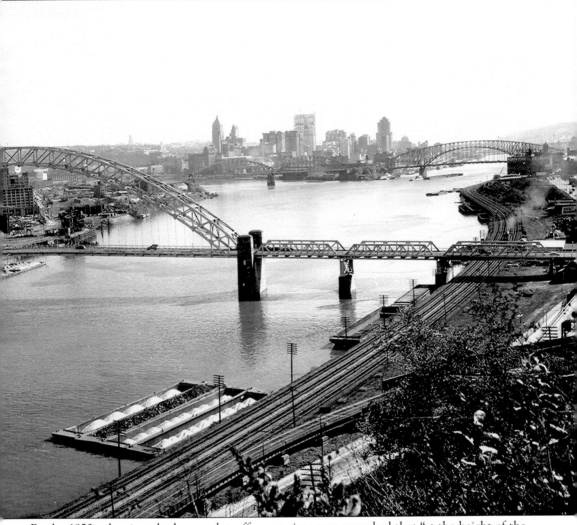

By the 1950s, the rivers had so much traffic, one river man remarked that "at the height of the busiest day, a man could walk from one shore to another without getting his feet wet." In 1951, a tally of daily river traffic included 1,690 towboats, 6,400 dry cargo barges, 1,500 tank barges, and nearly 200 self-propelled barges and passenger ferries. This total did not include general ferries and excursion boats, or sounding, survey, or personnel boats. (Carnegie Library of Pittsburgh.)

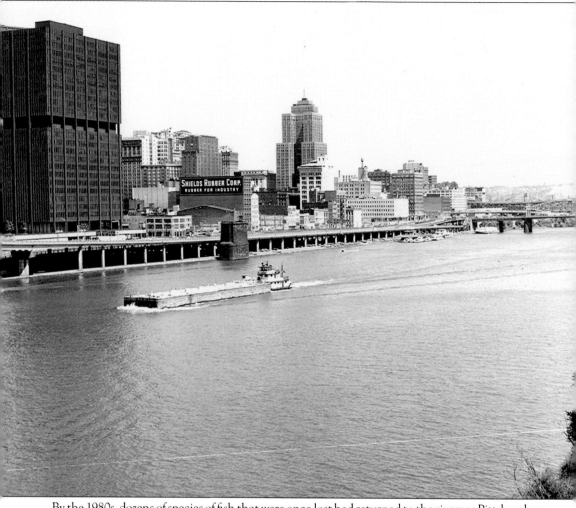

By the 1980s, dozens of species of fish that were once lost had returned to the rivers as Pittsburghers had reclaimed their natural resources. Thanks to stringent laws and water treatment efforts by towns and factories along Pittsburgh's waterways, the Monongahela, Ohio, and Allegheny Rivers are clean once again. (Carnegie Library of Pittsburgh.)

Ten

TODAY'S INDUSTRY

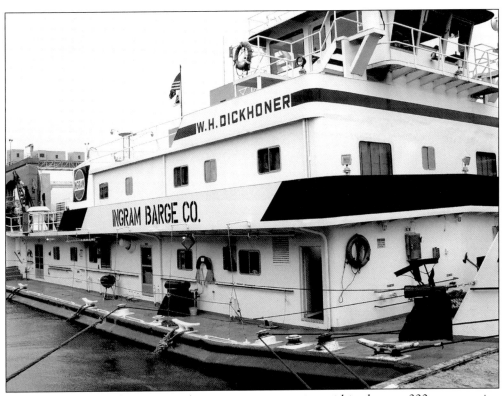

Although there have been many advances in transportation within the past 200 years, getting cargo from one place to another on the rivers has actually changed very little. With the exception of the establishment of dams and locks that enable the rivers to be navigable year round and advances in boat propulsion, moving goods such as coal, salt, and sand along the river is done in the same manner and at the same pace in 2006 as it was in 1806. Today the Ingram Barge Company is the largest inland waterway carrier in the United States, with over 4,000 barges and 140 boats moving those barges along Pittsburgh's rivers and beyond. (Daniel J. Burns.)

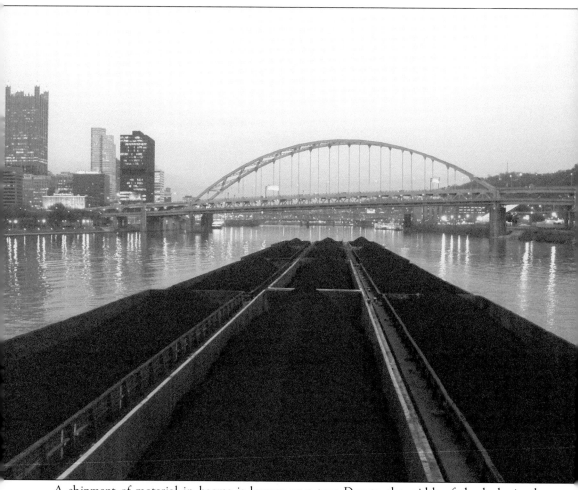

A shipment of material in barges is known as a tow. Due to the width of the locks in the Pittsburgh area, a tow can be only three barges wide and up to five barges long. One 15-barge tow is equal to a quarter of a mile in length. A full barge of coal is 1,500 tons, making a full tow equal to 45 million pounds of cargo. With this weight, and depending on river current, it can take up to two miles for a pilot to bring the tow to a stop. (Daniel J. Burns.)

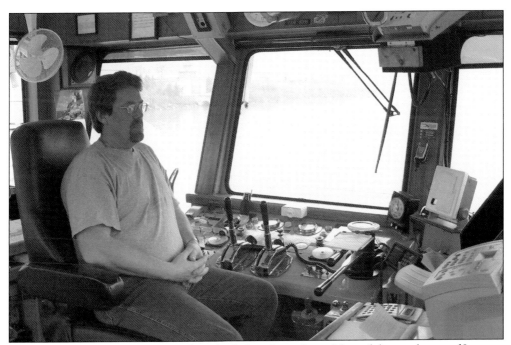

A river pilot takes his turn on watch at the helm of a towboat. Most of the employees of Ingram, as well as other companies, work their way up from deckhands before working in the pilothouse. (Daniel J. Burns.)

One of the new technologies of river transportation is the use of radar as a navigational tool. The images on the screen assist the pilot especially at night or in adverse weather by showing objects or other vessels in the water. In the old days, towboat pilots had to rely on their ability to "read the river" through visibly watching the river's currents and eddies. (Daniel J. Burns.)

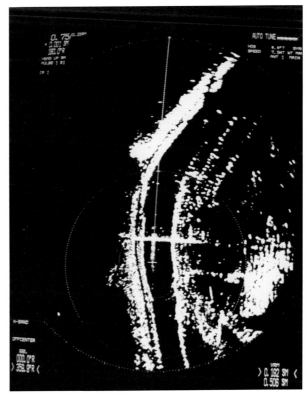

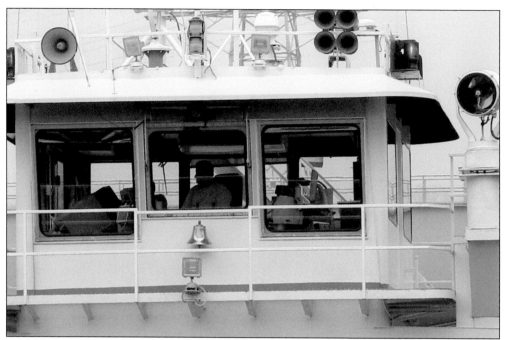

Aside from radar, the pilothouse is equipped with searchlights and spotlights, two-way radio communication, real-time GPS (global positioning satellite) technology, and sonar. All boats have computer and fax equipment, with most having access to the internet and e-mail. (Daniel J. Burns.)

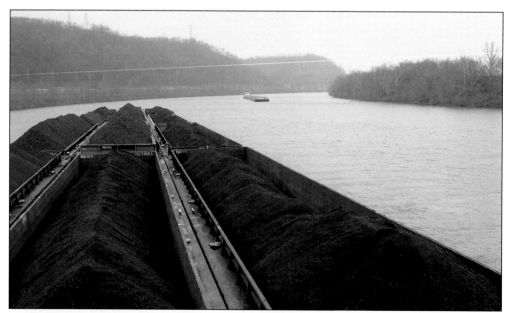

Much of the material that is moved along the rivers is done so because of low cost as opposed to train or truck travel. The average barge is 200 feet long, 35 feet wide, and 10 feet deep with the capacity to hold 1,500 tons of coal. To move this by train would require 15 train cars or 58 semi-tractor-trailer trucks. One full tow of coal (15 barges) would be equivalent to 870 large tractor trailers stretching for nearly 12 miles bumper to bumper. (Daniel J. Burns.)

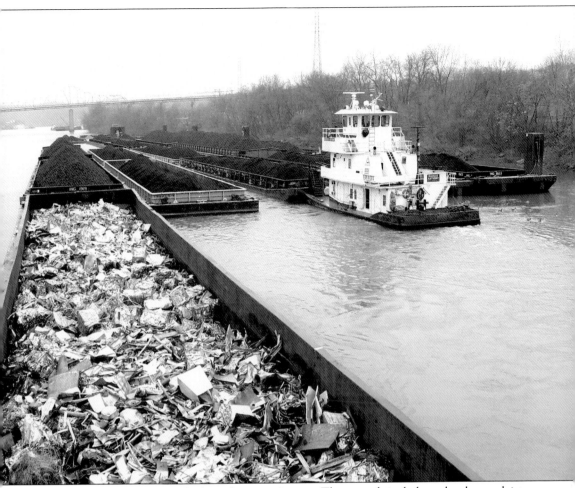

Barges transport many materials along the nation's rivers. These goods include coal, coke, steel, jet fuel, oil, pipe, wood pulp, lumber, sand, stone, and various metals, including scrap stainless steel, as shown here. In addition to raw materials, barges also carry many merchant goods. Throughout the industry, empty barges are often used to transport sailboat fuel. (Daniel J. Burns.)

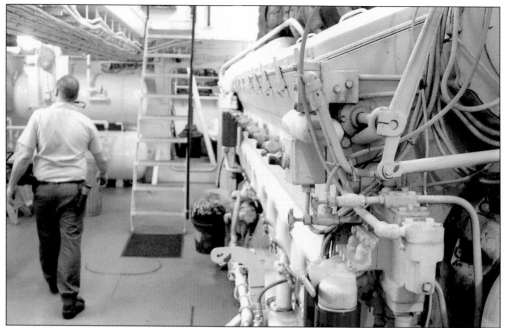

To be able to move the large barges filled with tons of material, today's towboats must have ample thrust. This boat, for example, has two 3,000-horsepower engines, the same engines that power train locomotives. Each motor powers a propeller in a large tube. This is called a kort nozzle and propels the boat by sucking water into the front of the tube and thrusting out of the back, making this an efficient and powerful means of moving the boat through the water. (Daniel J. Burns.)

The rudder system is hydraulic and powered by two electric generators. As with all of the systems aboard these vessels, this has a backup in the event of a primary system failure. (Daniel J. Burns.)

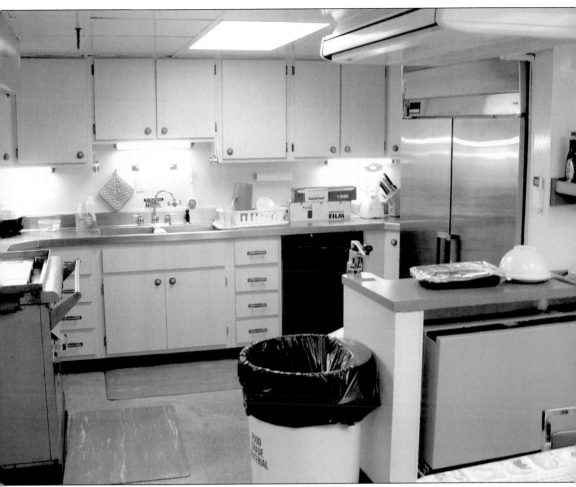

The boats that work along the rivers are well equipped and stocked for a month of travel. There are comfortable bunk rooms for the crew with shower facilities. There is a recreation room complete with satellite television and on some boats, satellite radio. There is also a washer and dryer and a complete galley. Members of the crew enjoy three nutritiously complete meals a day prepared by a full-time cook who also prepares snacks such as homemade cakes, pies, and cookies. (Daniel J. Burns.)

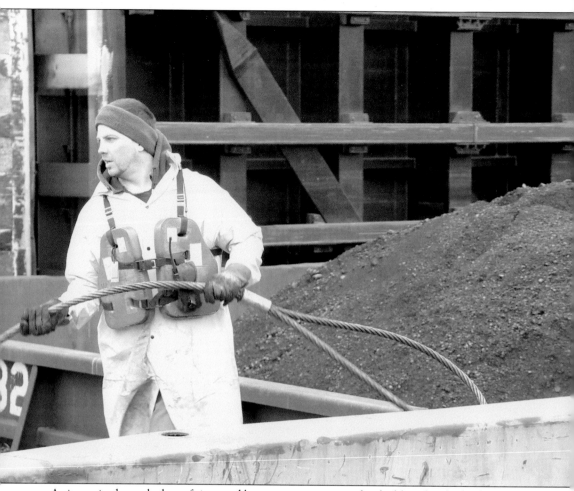

As it was in the early days of river and barge transportation, the deckhand is the backbone of the industry. These men and women work a 28 day on and 28 day off rotation. During their 28 days on the boat, they work a continuous six hours on and six hours off shift rotation. On the tow, they are responsible for checking the barges for water, maintaining all equipment and cables, and tying off the barges to each other and the mooring cells stationed along the river and the lock walls when traversing the lock chamber. They perform these duties 365 days and nights a year in 90 plus degree heat and in sub-zero temperatures. (Daniel J. Burns.)

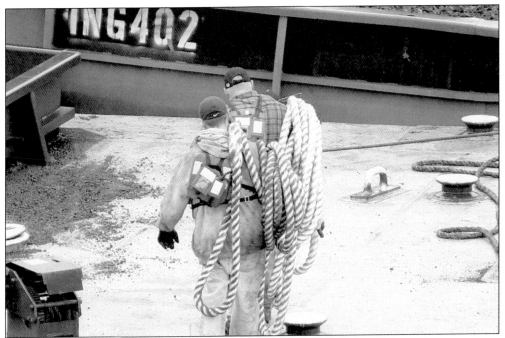

Deckhands must deal with all sorts of hazards, including the shifting of barges that cause lines to break. Large nylon ropes are used to secure the tow to various moorings. As the barges move and drift, these lines creak and "talk." When they stop talking is when they have stretched to their limit, and then they snap. (Daniel J. Burns.)

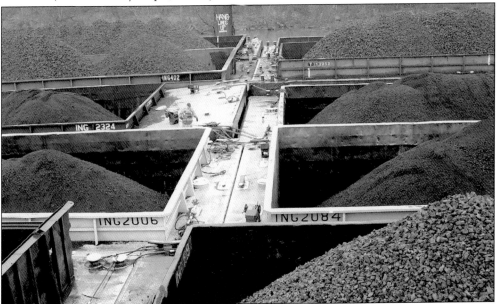

Each barge is numbered and staged for a specific location. To minimize shuffling by the towboats and deckhands, they are arranged on the tow by their destination. Different types of coal have industrial applications due to their sulfur content, so when one sees coal barges passing train cars loaded with coal, they are heading to completely different destinations for different reasons. (Daniel J. Burns.)

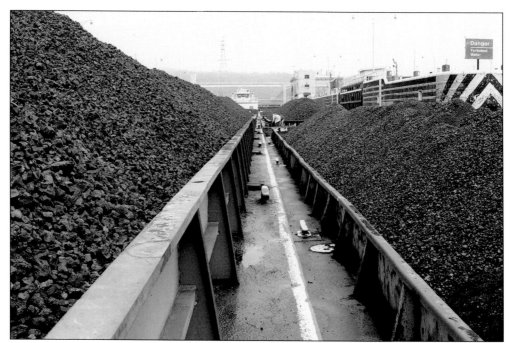

With a full tow a quarter of a mile in length, the pilot relies on his sight and the navigational tools in the pilothouse to assist him in navigating the river. The pilot must always be alert for other boats. The biggest concern to these towboat pilots is small craft boaters who too often do not realize that if they cannot see the sides of the barge, the tow is too close for the pilot to avoid the boater in the barge's path. (Daniel J. Burns.)

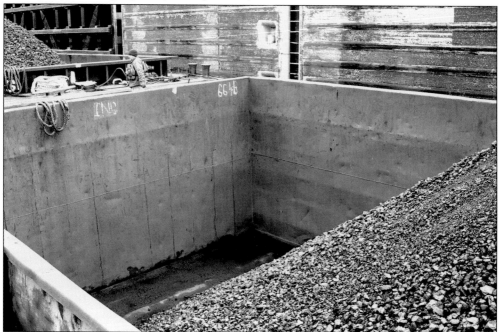

Because of the different types of materials transported in the barges, they must be cleaned often because the residue from some loads can contaminate others. (Daniel J. Burns.)

Once in the lock, the deckhands must secure the barges to the sides of the lock chamber. As the lock fills or empties, the deckhand must, by hand, maintain a taut rope to keep the barges from moving within the chamber. (Daniel J. Burns.)

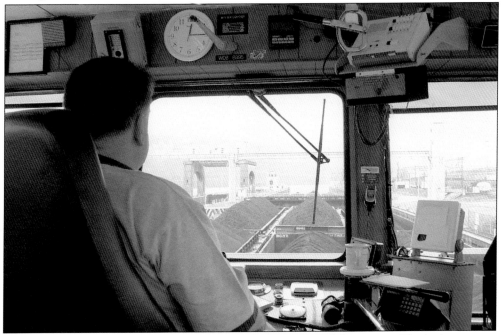

Like threading a needle, a tow three barges wide measures 105 feet across. The lock measures 110 feet in width. With two and a half feet left on either side of the tow, there is little room to spare. Of course, it is the deckhand at the top of the tow with a two-way radio guiding the pilot into the lock. (Daniel J. Burns.)

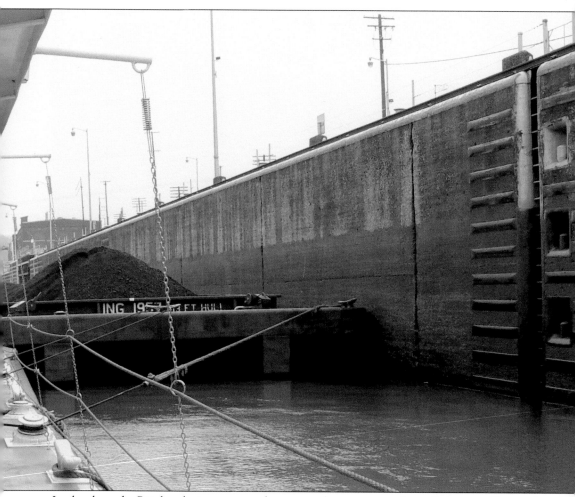

Locks along the Pittsburgh rivers are not large enough to accommodate a large tow of barges. In that case, the towboat pushes only some of the barges through the lock. Once through, they are tied up on the opposite side until the remainder of the tow passes through. This process can take up to two hours to complete. On the river, one can never be in a hurry. (Daniel J. Burns.)

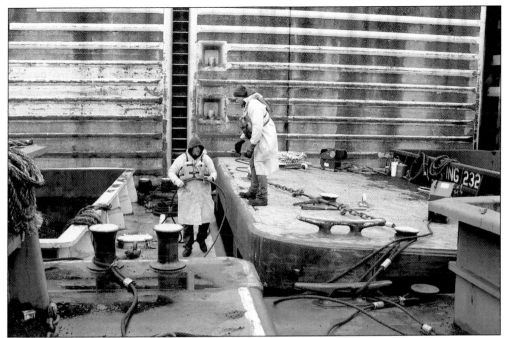

Working on a riverboat requires following many rules. Crewmembers act as a team and are required to perform all their tasks in a safe and professional manner, keep themselves and their living quarters presentable, respect their fellow shipmates, report for their shift on time, and follow all company policies and know all emergency procedures. Safety is always the most important issue. (Daniel J. Burns.)

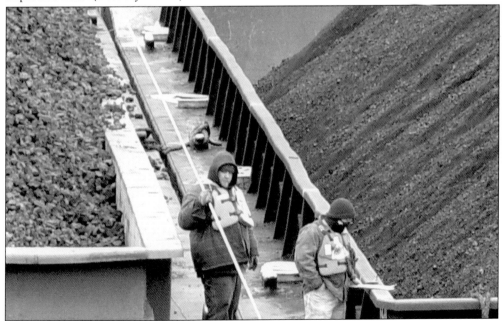

Deckhands are also required to follow certain etiquettes of the boat. These include maintaining good personal hygiene, being presentable at all meals with clean clothes and combed hair, and respecting other crewmembers by not using foul language. (Daniel J. Burns.)

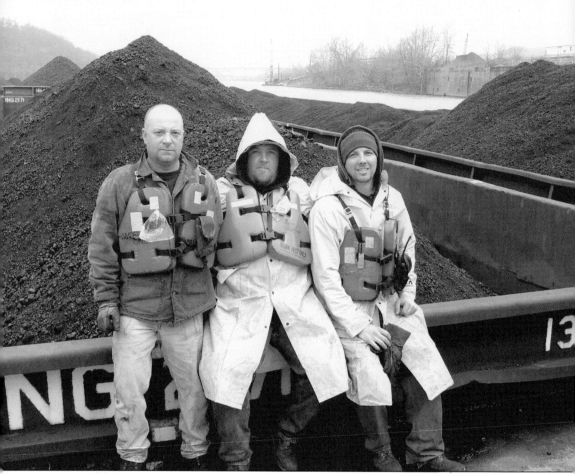

Working and living on the river has always been and will always be a rough life. These men and women are away from their families and loved ones for long periods of time. Mostly everyone in the industry knows someone who has been seriously injured or has lost their life working on the river, yet one will find many second, third, and even fourth generation towboat pilots, captains, and engineers. From the captain to the cook, these people are proud to be part of a family that takes care of and looks after one another as they have for over 200 years. In their eyes, one is either "on the river" or "on the bank," and those that are "on the river" would not have it any other way. (Daniel J. Burns.)

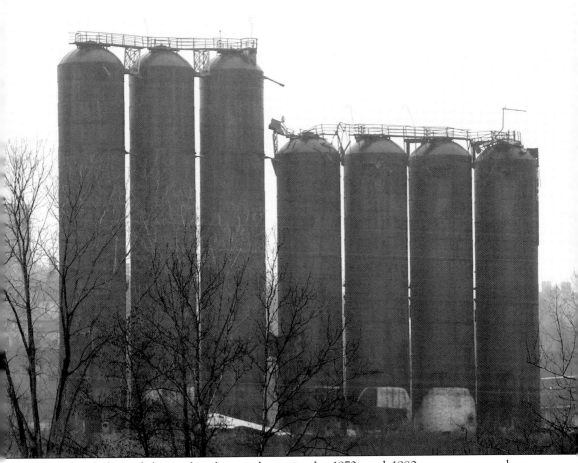

With the decline of the steel making industry in the 1970s and 1980s, many towns along Pittsburgh's rivers that were once bustling with activity and production were silenced and left to rust. The Duquesne Plant of U.S. Steel, shown here, was one of these casualties. Boats that once docked here loading and unloading barges full of coal and coke now only pass by these deteriorating hulks along the river's bank. Like many others before, this industry came and went while the rivers remained constant. (Daniel J. Burns.)

DISCOVER THOUSANDS OF LOCAL HISTORY BOOKS FEATURING MILLIONS OF VINTAGE IMAGES

Arcadia Publishing, the leading local history publisher in the United States, is committed to making history accessible and meaningful through publishing books that celebrate and preserve the heritage of America's people and places.

Find more books like this at
www.arcadiapublishing.com

Search for your hometown history, your old stomping grounds, and even your favorite sports team.